Creative Calligraphy

A complete course

Creative Calligraphy

Marie Lynskey

Thorsons
An Imprint of HarperCollinsPublishers

Thorsons
An Imprint of HarperCollins*Publishers*
77–85 Fulham Palace Road,
Hammersmith, London W6 8JB

Published by Thorsons 1988
7 9 10 8 6

A catalogue record for this book
is available from the British Library

ISBN 0 7225 1509 X

Printed in Great Britain by
The Printhaüs Book Company,
Wellingborough, Northamptonshire

To Steve

Contents

Introduction

To most people, a hand written document has a special quality which gives it greater value than a printed page. For example, a printed certificate, obviously mass produced, with only the name entered by hand can seem to the receiver rather impersonal and lacking in significance whereas a completely hand written document into which more time and care has been put would be received with much greater pleasure. Medieval manuscript books in museums are viewed with an interest and enjoyment never likely to be inspired by the hundreds of printed volumes since produced. It is possibly the knowledge that the words in front of your eyes were written by someone's hand rather than mass produced on a machine, giving them a unique quality, which makes them something to be treasured.

Handwriting itself is a skill which most people learn and master whilst very young. To take the learning of lettering a step further and make it not merely functional but a thing of beauty only requires the learning of the correct letterforms, some basic rules, and a great deal of practice. It is therefore within most people's capabilities, if they are prepared to give a lot of time to practising, to master the art of beautiful and decorative writing or 'calligraphy' for themselves. Once the basic letterforms have been learnt and can be written with ease then you have paved the way to creating a wide range of beautiful documents and works of art.

In this book you can learn, from the initial steps to forming pleasing letters, through building up well designed pages and making simple items such as cards and posters, to more elaborate pieces such as certificates, family trees, and even re-creations of medieval illuminated manuscripts. In addition to lettering, you will learn many practical accompanying skills, such as applying gold leaf, preparing a skin of vellum and making ribboned scrolls.

From the point of view of the beginner, one of the good

things about calligraphy is that it is very inexpensive to equip yourself with the basic tools and little space is needed in which to practise. As you progress you will find that you gradually build up a store of other useful equipment, but these things will only have been acquired after you have had time to decide that calligraphy suits you as a hobby. If you find that it is not for you then you are not left with a great deal of expensive equipment.

This book should be useful to calligraphers at all levels as not only have the learning stages been dealt with comprehensively, but also, for those who have perhaps made a start from a book dealing only with the basics and then been left to their own devices to progress further in the subject, there are many intermediate projects and also more complex illumination techniques for advanced students.

With determination and perseverance, by the time you have reached the end of the book, you will have learnt how to create beautiful works of art which will excite the admiration of many, and may even become a source of income.

1 Materials and equipment

Today there is a wide range of calligraphic equipment available in art shops and stationers. The newcomer can be faced with a bewildering selection. To choose and get the best out of his equipment it is necessary for the calligrapher, as with any craftsman, to acquire a good knowledge of it. He will then be able to select the items which best suit him and the task in hand in order to accomplish the most satisfactory results. There are many new and unfamiliar terms to be met with in the description of pens, papers, etc., so in this initial chapter I have endeavoured to acquaint the student with those most frequently met.

The initial requirements are fairly simple and I have suggested what I consider to be the most suitable products for learning. A list of suppliers of the items mentioned will be found at the back of the book. I have also included some more advanced equipment which you will want to use as you progress.

In addition to equipment that can be purchased there are some items which the calligrapher can make for himself if he has the inclination. Many of the traditional tools of the scribe were made by individual craftsmen, and there is something very pleasing about writing with a pen which you have made yourself. Experimenting with such things as these adds to your understanding of the craft, promoting an improved standard of work.

The pen

The pen is the most important piece of the calligrapher's equipment and therefore it is essential that a good make is chosen. An excellent choice, and that most widely available in art shops (see List of suppliers, page 158), is the William Mitchell 'Roundhand' pen by Rexel. These pens are comprised of three

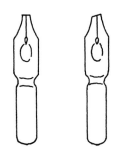

(**Fig. 1**) *Square-cut Left oblique*

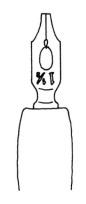

(**Fig. 2**) *Nib inserted correctly into pen holder*

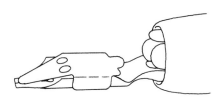

(**Fig. 3**) *Reservoir correctly fitted onto nib*

(**Fig. 4**) *Alternative types of edged pen. (a) Fountain*

parts, a holder, a nib and a reservoir. The nibs are made of metal and come in a range of sizes from 0, the largest, to 6, the smallest, with some half sizes giving a choice of ten different sizes. Those who are right-handed should use the square cut nib whilst a set of oblique cut nibs has been produced for left-handed people (Fig. 1).

A good size with which to begin is a 1½; this is fairly large and will show up mistakes clearly for you to correct and so improve your letters. The William Mitchell holder is made of plastic with a metal insert for holding the nib—this is fitted between the metal insert and plastic outer edge. The nib is pushed in as far as its curved neck and before the impressed number, just under halfway down the nib (Fig. 2). If not pushed in far enough the nib will move from side to side as you write, if too far there will not be enough room to hold the reservoir.

A 'No.2 Slippon' reservoir is used to enable a small amount of ink to be held on the nib so that it can flow out smoothly and gradually as the pen writes. It is positioned over the nib with the tip of the reservoir about 0.5-1mm from the tip of the nib (Fig. 3). The tip of the reservoir should only barely touch the nib; if it is too tightly pressed against the nib the ink will not flow freely, and if the gap is too wide it will flood out too rapidly. You only need to buy one holder and one reservoir with which you can use all the nibs, but it is sometimes useful to have several pens with different sized nibs ready for use on a piece of work.

Another very good make is the 'Speedball' nib, though it is slightly more expensive than the William Mitchell nib. These nibs come with reservoirs attached above the nib so the ink is held on top of the nib as it writes. 'Speedball' nibs are made by an American company so are not so widely available in this country.

There are many other types of pen on the market, for example a range of calligraphy fountain pens with interchangeable nib units (Fig. 4a), these are quite capable of producing good lettering but do not give quite the sharpness of line that can be obtained from the 'Mitchell' nibs. Whilst useful in that the necessity of frequently refilling the pen is removed by the use of cartridges or refillable reservoirs, you are limited to using only the ink that is manufactured to go with the pens and this tends to be rather thin and transparent which is not very desirable in calligraphy where a good strong black is usually required.

Most fountain pens have a rather limited selection of colours, though the 'Artpen' range made by Rotring has been designed to take their set of 'ArtistColors' and from these you can mix almost any shade you want.

Automatic pens and Witch pens (Figs. 4b and 4c) are two types of pen which do not require separate reservoirs, they have a type of built in reservoir and as a result the definition of the

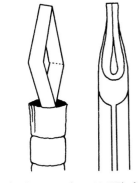

(b) Automatic (c) Witch

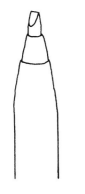

(d) Fibre-tip

(Fig. 5) (a) Copperplate nib

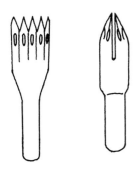

(b) 5-line music pen (c) Scroll nib

letters is lost. They can, however, make reasonable strokes and may be used if 'Mitchell' nibs are unobtainable.

Another type of calligraphic pen available is a wedged fibre tipped pen (Fig. 4d). This again is useful for some kinds of practise and design work, especially where you require a large sized nib (the smaller sizes tend to be rather inaccurate) but they do not have the same 'feel' as a metal nib and are no long-term substitute. They do not have a very long life and tend to go soft and fuzzy after a few weeks' use. They are obviously of no use for finished articles.

A nib which is pointed and has a sharp elbow bend (Fig. 5a) is used for Copperplate writing. Copperplate requires a much greater degree of control and practise and is different from other forms of calligraphic lettering in that it resulted from the invention of printing rather than the natural use of the pen (see page 64). Lettering was inscribed on copper printing plates with the use of an engraving tool and naturally evolved into the beautiful flowing scrolls and loops that are characteristic of this hand. It became so popular that calligraphers were required to produce a similar hand-written alphabet. Copperplate involves a different technique to lettering done with an edged pen.

Poster nibs are available which are basically the same as the Roundhand nibs but larger. They have individual reservoirs already attached and are useful for very large lettering. Because of their size it is sometimes difficult to get an even flow of ink along the whole edge of the nib continuously.

There are music pens with five points for drawing music staves (Fig. 5b). They are also great fun for decorative writing or borders, but it is extremely difficult to get the ink flowing freely from all five points at once. Scroll pens (Fig. 5c) are another type—they make a double line—and there are many others with which, once you are proficient, you can experiment and discover interesting patterns and letterforms for use on decorative pieces of work.

Reed and quill pens

The reed pen is one of the oldest writing instruments and was introduced by the ancient Greeks. These pens are so easy to make that it is well worth attempting one or two and you can obtain good results with them. In addition, the reed is a light, sensitive tool which can produce delicate and subtle effects not easily achieved with a metal nib.

All you need is a very sharp penknife or a scalpel, a hard flat surface on which to make some of the cuts, and a reed. Reeds are rather hard to come by in this country, so if you have difficulty in obtaining one try instead a bamboo cane which can be bought from most garden centres. Bamboo is more rigid than reed so it does not make such a good pen, but a bamboo pen can still be a

(Fig. 6) Cutting a reed pen

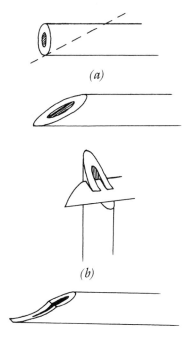

(a)

(b)

(c)

(d)

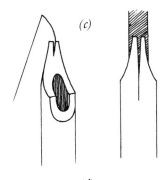

(Fig. 7) Primary flight feathers

tolerable writing instrument. Cut a piece about 7 inches (18cm) long and slice off the end diagonally (Fig. 6a). Some reeds are very tough, so do not worry if you have to make several attempts before you get a good straight cross section. Now make a second cut (as shown in Fig. 6b) making the end of the nib the width you require. When you make this cut you should try and remove all the soft inside part of the reed and leave a fairly thin tapered end; you can pare away any unwanted thickness carefully and adjust the tip to the required width if necessary. Make a small slit in the end (Fig. 6c) then turn the pen around and, using a pencil pressed against the back, carefully make the slit longer, about ¾ inch (2cm) should be enough. Finally lay the end of the pen on a hard flat surface such as a glass slab and cut off the tip with one straight vertical stoke downwards (Fig. 6d).

Reed and bamboo canes come in fairly thick sizes so you can make large nibbed pens from them which are useful for poster writing. They are not so good for very small writing as they tend to become rather indelicate when cut too narrow.

The quill pen is well known as a writing instrument. It requires more preparation than the reed but produces the finest writing possible. Beautiful, sensitive strokes, and fine hairlines can be produced. This was, of course, the writing instrument used extensively throughout the Middle Ages and until it was superseded by the metal nib in the nineteenth century.

Quill pens are made from primary flight feathers (Fig. 7) of large birds, mainly swans, geese, and turkeys, and sometimes ducks and crows. The leading edge of the wing provides these feathers, the best being the first four or five because of their strength.

The first thing to do when preparing a quill is to strip away the barbs (Fig. 8). Contrary to many romantic pictures these do not remain on, they will hamper the smooth manipulation of the pen by brushing against the hand where the pen rests. (A few can remain on the end if desired, where they will not interfere.)

Next the quills must be cured. They are hardened so that they will not wear out too quickly or become distorted when used. Quills are also covered with a membrane which must be removed as it would interfere with the accuracy of the nib. Cut the ends of the quills off and soak them in water for several hours to make them more pliable and easier to cut—they are then plunged into hot sand which will harden and clarify them. Heat some sand, about 2 inches (5cm) deep (this should be as fine as possible—L. Cornelissen & Son (see List of suppliers, page 157) can supply sand of suitable quality) in a shallow pan then plunge the quills into it so that the sand goes right inside the barrels. The quills need to remain in the sand for a few seconds only, but this will depend on the temperature of the sand. The soft pithy inside should shrivel and they should become transparent.

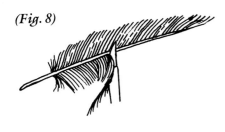

(Fig. 8)

(Fig. 9) *Cutting a quill pen*

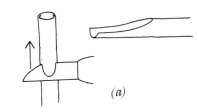

(a)

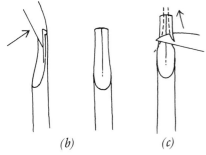

(b) (c)

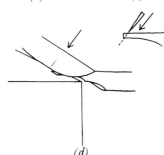

(d)

(e)

Magnification of final nib end

Curing quills is a matter of learning by trial and error, adjusting the heat and the length of time the quills are in the sand until you achieve the correct result. When the quills are withdrawn from the sand the outside membrane is removed by scraping the surface of the barrel carefully with a knife. The quills should be removed from the sand as soon as they begin to appear transparent; leaving them in too long will make them brittle and useless. You will be able to tell if your quills are too brittle because they will crack and split incorrectly when you cut them; if not left in the sand long enough they will remain too pliable and will not stay in shape long when used, and you will have difficulty in lengthening the reservoir slit when you reach that stage.

For those who wish to omit the curing process ready cured quills are available from L. Cornelissen & Son. This company also supply quills cut to size according to your requirements.

If you intend to cut the quills yourself the process is very similar to reed cutting. First the end is cut off with a long scooping cut (Fig. 9a). Next make a slit in the end with the knife and lengthen it carefully by levering the knife back and forth (Fig. 9b). The sides are then cut away, one at a time, (Fig. 9c) taking care to get both sides evenly matched. Turn the nib over, placing it on the edge of a hard surface and make an angled cut on the tip of the quill (Fig. 9d) then make a final cut at the very end of the nib straight downwards (Fig. 9e).

You can make a reservoir for either quill or reed pens by cutting a thin strip of pliable metal sheet about 1/8 × 2½ inches (4mm × 60mm). Donald Jackson, in *The Calligrapher's Handbook*, suggests the use of metal drinks cans for this purpose, the metal being of ideal thickness. Bend the strip into an 's' shape as shown in Fig. 10a and carefully round the ends off before placing it inside the nib so that the end of the reservoir overlaps the slit made in the barrel (Fig. 10b). Quill pens can be recut when they become blunt.

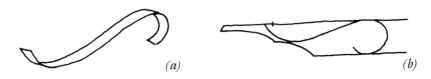

(a) (b)

(Fig. 10) *Making a reservoir for a quill or reed pen*

Ink

Many bottled inks are available which are adequate for practice work but very often these are not opaque and do not give the lovely crisp lines and smooth flow obtained from using Chinese

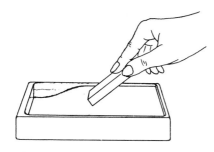

(Fig. 11) Chinese stick ink being ground on an ink slate

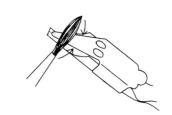

(Fig. 12)

stick ink. This is more difficult to find locally, but is available by post from Falkiner Fine Papers (see List of suppliers on page 157). You should also buy an ink slate on which to grind the ink for use. A little distilled water is placed in the welled end of the slate and the ink stick is ground over the whole surface with a fairly heavy pressure for several minutes until the ink is the required blackness (Fig. 11). The ink stick should be carefully dried afterwards to prevent cracking during storage. If you decide to use bottled ink buy a good make such as 'Stephens' or 'Higgins' Drawing Ink rather than one of the extremely transparent types manufactured for ordinary fountain pens.

The ink from the slate or bottle is applied to the pen with a small paint brush, the brush is dipped into the ink and the nib is filled by drawing the loaded brush across the gaps between the reservoir and the nib, forcing ink into the gap (Fig. 12). This method of filling the pen may seem fussy but is infinitely preferable to dipping the nib into the ink which will result in ink getting on the front and back of the nib where you do not want it. If you use this method of pen filling you need to wipe the ink off these areas each time, which is time consuming and wasteful.

Paper

Paper is made by breaking up rags or wood pulp into separate fibres which are mixed with water then spread over a wire mesh tray in a thin layer. Rags make stronger paper than wood fibres, 100 per cent rag content making a very good quality paper. The layer of pulp is then pressed onto a felt cloth to dry. The process by which the paper fibres are laid onto the tray makes one of the main differences between handmade and machine-made paper. With handmade paper the action of the paper maker shaking the fibres about to get an even layer of pulp leaves the fibres laying in all directions. Machine-made paper is formed by the pulp being poured onto a moving belt; the motion of the belt causes the fibres to lay more in the direction it is moving, forming a 'grain' direction. The paper is weaker 'with the grain' as you can find out for yourself by tearing a sheet of newsprint. Tearing in one direction will produce a fairly even line whilst the other direction will produce a more ragged line. Handmade papers, having no particular grain direction, will be equally strong in all directions. This is an advantage for calligraphy as you will be doing pieces of work which you will obviously want to be strong and lasting.

Papers will sometimes be referred to as 'laid' or 'wove'. 'Wove' papers are smooth whilst 'laid' paper has a lined surface. This is due to the type of tray or mould used for collecting the layer of pulp. Wove papers are made on a cloth mould whilst laid papers

are made with a wire mould which has had slightly thicker wires laid across at regular intervals. The pulp layer over these thicker wires will be slightly thinner and when dried and held up to the light the lines can be seen.

Watermarks are produced on paper in the same way, a design of wire threads in the shape of the required watermark being added to the surface of the mesh tray. The paper is again slightly thinner over these parts allowing more light to show through and the design to be seen. It is generally considered proper to have the watermark the right way round on a piece of work but this is a fairly trivial point and sometimes not practical.

Paper is generally too porous if left to dry without any other preparation, so it is 'sized' i.e. the paper is treated with a substance which will prevent ink or paint from soaking in and spreading when it meets the surface. Sizing is carried out either by the paper being passed through a bath of the sizing preparation and then dried again or by adding the size to the liquid pulp before the sheets are made. The calligrapher needs a paper which is sized sufficiently so that the ink will not sink into the surface and spread, but also one that is not so heavily sized that the ink cannot penetrate the surface at all and sits on it in pools.

Finally, the surface of the paper is 'finished' if required. A smooth surface is achieved by running the paper through rollers or polishing with burnishers. You will see papers termed 'hot-pressed' (HP) or 'not hot-pressed' (NOT) which refers to how the surface was finished. Hot-pressed papers are more likely to be useful to calligraphers as a fairly smooth surface is required. Too rough a surface will cause the pen to catch on the loose fibres, spoiling the work.

Machine-made papers are made in long rolls and then cut into pieces. You can buy uncut rolls of paper which are useful for large pieces of work.

The paper thickness is usually described in GSM (grammes per square metre). A thin typing paper is about 60 gsm. This is a little too thin for calligraphy, the paper tends to cockle when the wet ink meets it. It can, however, be used for layouts and rough work, but the beginner should not use thin paper on which to practise as a cockled writing surface will just give additional problems and distraction to a student coping with learning letterforms. The best paper on which to start is 100 gsm cartridge paper, available in most stationers and art shops. For finished pieces of work 160 gsm is a good weight, being stout and hard wearing. In a good paper shop you will find a variety of weights and surfaces with which to experiment.

The traditional surface for calligraphy is vellum or parchment, which is the skin of calves, sheep, and goats. This is still made today but is rather expensive and should only be used for

important finished pieces. The preparation and use of vellum is explained in Chapter 8.

Work surface

Calligraphy should be written on a surface that is sloped. The pen and hand meet the surface at a comfortable angle and you are able to see what you have written as you progress through the page. If a flat surface were used the letters would be likely to be slightly distorted, as the top part of each letter would be further from the calligrapher's eye than the bottom. Anyone who has had dealings with perspective will know that objects further away appear to get narrower. In addition you would find that your pen would be held at a steeper angle causing the ink to flood out too quickly.

The simplest way for a beginner to achieve this sloped writing surface is by balancing a drawing board against a table and resting it upon the lap. A piece of blockboard about $2\frac{1}{2} \times 2$ feet (70×60mm) and about $\frac{1}{2}$ inch (1.25cm) thick can be obtained quite cheaply from a do-it-yourself shop. Although this will do as a makeshift arrangement you will probably find it inconvenient after a time when you need to move to reach something and the whole set up has to be put aside. I always feel rather restricted with a drawing board which moves too freely and therefore requires caution to prevent jogging. I have found too, whilst teaching students who are using makeshift equipment, that after an hour or two balancing a drawing board on the lap tiredness can cause unsatisfactory positions to be adopted and the board is allowed to drop to too shallow an angle.

Ultimately therefore the student should aim for a fixed-angle drawing board; one with a stand which can be placed on an ordinary table or desk is the most practical. You can buy drawing boards with parallel rules attached which are a very useful aid when ruling a page of lines. If a shop bought board is too expensive it is not difficult to make one yourself or get a keen 'do-it-yourself' friend to make a simple stand against which to rest your board. Fig. 13 shows a simple angled drawing board which is easily constructed.

A 45 degree angle of slope would be comfortable for the average person. This can be altered if you find yourself preferring a slope steeper or shallower. Most shop bought boards have adjustable heights for you to choose the angle that most suits you.

When you have obtained your drawing board, cover the surface with several large sheets of blotting paper taped or pinned down at the sides—try to have the paper reasonably taut. This gives a slightly springy surface which is preferable to the

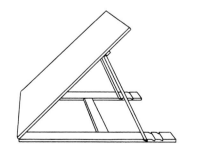

(Fig. 13) *Simple angled drawing board*

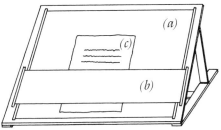

(Fig. 14)
(a) blotting paper
(b) guard sheet
(c) work surface

smooth hard surface of the board. To avoid your hands coming into contact with the writing surface make yourself a guard sheet (Fig. 14). No matter how clean, your hands will always transfer a small amount of grease or dirt to the surface of your work, and apart from making the page dirty this could cause problems as greasy patches on the paper will not take ink. In a later chapter I will explain how to treat paper which has this problem.

For the guard sheet a piece of thick, stout paper such as sugar or blotting paper about 8-10 inches (20-25cm) deep and the width of your drawing board is placed just below the height at which you can comfortably work and then taped to the sides of the board. The page on which you are going to work is slid down under this guard sheet so that the part of the page about to be written on shows just above it; the writing hand will rest naturally on the guard sheet as you write. As you reach the end of each line the page is pulled up to reveal the next writing line.

It is handy to have beside you a piece of soft cloth or absorbent kitchen paper for cleaning the nib and wiping it dry. Also a piece of scrap paper is useful for trying out the pen before you write in order to get the ink flowing and to make sure you do not have an over-full nib which could produce a blob of ink on the page.

T square

If your drawing board does not have a parallel rule attached then a T square can save you a lot of time and trouble when drawing up lines. For the right-handed user it rests over the left-hand edge of the drawing board and is slid up and down to give parallel lines square to the board and paper (Fig. 15). Without this item you would need to use the painstaking method of drawing sets of three points in a row across the paper and joining them up.

Lighting

Natural light is obviously the best in which to work, so have your work area next to a window if possible. When natural light is not sufficient you will need a good artificial light. You can buy adjustable lamps which clamp onto your table or desk or a free-standing draughtsman's lamp. You do need a good light that is as close as possible to natural light, as when you are working with colour, artificial light tends to distort the colours to some degree. Too strong a light will reflect off the page and the glare would cause tiredness and strain to the eyes. If you are right-handed then your light should come from the left so as not

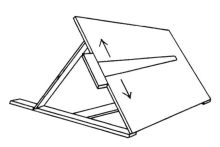

(Fig. 15) *T square used for ruling sets of parallel lines.*

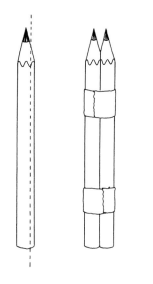

(Fig. 16) Constructing double pencils

to throw a shadow from your hand onto the work—the reverse applies for left-handed people.

Pencils

An assortment of pencils of different grades of hardness (H) and blackness (B) will be useful. Pencils are not made with lead but with powdered graphite mixed with clay. Different grades of pencil are made by altering the proportions of clay and graphite; the larger the proportion of clay the harder the pencil. Coloured pencils are made with a mixture of clay and coloured pigment rather than graphite. There are 20 grades of graphite pencil, from 9B which is a very soft lead giving a fuzzy and very black line, through to 9H which is a very hard lead giving a crisp, faint line. In the middle of this range is the HB pencil, which is quite adequate for sketching and general purpose uses, and the F which is also a good sketching grade. A hard pencil such as a 5H or 6H would be used for tracing through transfer paper where you need to impress the lines through several thicknesses. The softer B pencils can be used on roughs where shading is needed.

Mechanical pencils into which different lead grades can be fitted are, in my opinion, no advantage as the leads are awkward to change, difficult to sharpen and, being heavier in the hand, they restrict freedom of movement. You can buy chisel shaped pencils from carpentry shops with wide leads which can be used when practising lettering.

Another good practise tool is a set of double pencils. These are easily made by taping two pencils together (Fig. 16). It is easy to vary the width of the two points by shaving off more or less of the wood on each of the sides that meet. Making letters with double pencils can be useful; you can see from the double lines how the strokes are joined together (see page 33).

Colour

As soon as you have reached the level where you want to start producing finished pieces you will undoubtedly want to use colour. Coloured inks are available but are not very satisfactory for calligraphy as they are very thin and flow from the pen too quickly, producing blotchy writing of varying thicknesses. They are also transparent, which is not a desirable quality, and tend to gel in the nib after a while, causing difficulty in cleaning. Paint is therefore preferable and Winsor and Newton's 'Designer's Gouache' is a very good choice. It comes in a wide range of colours and is available in most art shops. It can be bought in tubes or cakes. Gouache is mixed with water and flows through

a nib smoothly, but the nib needs to be dipped in water occasionally and cleaned to avoid clogging when the paint dries on it. 'Pelikan' gouache colours available in tubes and bottles are also very good.

With gouache paint, over-mixing can dull the brilliance of the colours and give them a muddy appearance. For this reason there are a wide range of colours so that mixing can be kept to a minimum. To help the beginner in his choice I have listed below those which are the most useful from the Winsor and Newton range of over 80 colours.

Scarlet Lake	This is a bright red which is most useful for illumination by itself or with other colours
Madder Carmine	A deep red for shading on Scarlet Lake
Cobalt Blue	Mixed with a little Ultramarine, this colour makes a good mid-blue for use as a base colour
Ultramarine	A very strong, brilliant colour used for shading on the above colour or for illumination on its own. As the colour tends to be a little transparent a touch of white can be added to make it opaque
Prussian Blue	Used for the darker blue shades and mixed with Van Dyke Brown to make a steel grey for use on 'metal' coloured objects
Permanent Middle Green	A very good colour for illumination but contrary to its name the colour is less durable than the others mentioned. More permanent greens are available but they are less attractive in colour
Permanent Light Green	A brighter more yellow green used for highlighting the above colour
Spectrum Yellow	A very bright golden yellow

Lemon Yellow or *Cadmium Primrose*	For when a lighter, fresher yellow is required or for highlighting
Yellow Ochre	A pale brownish yellow
Naples Yellow	A rich cream
Marigold Yellow	This is more of an orange than a yellow, and mixed with white and Lemon Yellow is a better highlighter for red than pink tints
Van Dyke Brown	A fairly dull mud brown
Burnt Sienna	This is a much richer chestnut brown
Parma Violet	This is a fugitive colour and therefore should be avoided if possible. However, purples are difficult to mix and on some work it may be the only choice if a striking purple is required
Zinc White	For lightening all colours
Ivory Black	For making shades. Never use straight from the tube where black alone is required, a touch of white will not remove the black look but will prevent the colour appearing to jump out of the page too strongly

Pure powder pigments can be bought from specialist shops and have some advantages over ready mixed colours, in particular their brilliance and the absence of certain ingredients which can damage some writing surfaces. Their disadvantage is their messiness and need for extra preparation. Methods of preparing powder colour are explained in Chapter 8.

Acrylic paint which is mixed with water but becomes water resistant when dry can be useful on occasions (see page 98).

Another method of adding colour to your work is gilding. The addition of a little gold to a piece of work can transform it amazingly, and the various methods of applying gold will be dealt with in Chapter 8 along with the tools required for the job.

A selection of suitable brushes, palettes, powder and tube colours

Palettes in which to mix paint come in all shapes and sizes, and whilst many do the job adequately a deep china 'well' is preferable. A flattish container will allow the paint to dry out more quickly and a plastic container is easily spilt or upset, but a china well, if covered, will keep your paint moist and fresh with no risk of tipping over.

Brushes

For detailed illumination you will need small, good quality, sable brushes. The Winsor and Newton 'Series AAA' is ideal and the sizes 0 and 1 will be the most useful. A slightly larger size can be used for painting in very large areas of colour. A brush for applying ink to the pen need not be of high quality but make sure that you do not get one from which the hairs continually fall out.

Other equipment

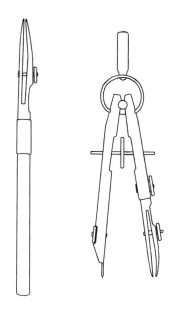

(Fig. 17) Ruling pen and compass

Geometrical instruments

Anyone who has studied the beautiful Lindisfarne Gospels has probably marvelled at the complex and intricate pages of geometrically calculated patterns. Scribes used any tools that would make their work more exact and lacking in imperfections. The same still holds true today so that although there is a great deal to be admired in freely drawn illumination, the calligrapher need not draw back from the use of mechanical instruments to achieve his intended design. Therefore make free use of rulers, compasses, set squares, protractors, etc.

An invaluable aid is a set of ruling pens and compasses. A simple boxed set with attachments for lengthening the instruments and interchanging them with the normal compass and divider points will suffice (Fig. 17).

Flexicurves can prove useful and are available in many graphic suppliers and art shops. You could include an 18 inch (45cm) ruler in your equipment as an ordinary 12 inch (30cm) ruler is often not long enough. Transparent plastic rulers are the best and it is a good idea to buy one that is marked in imperial measurements on one side and metric on the other as at some time or other you will probably need both types of measurement.

A metal ruler will also be needed for cutting paper as the edge of a wooden or plastic ruler would soon become nicked by the knife's edge.

Cutting tools

The recommended paper and vellum cutting knife is a Stanley Knife which has a retractable blade for safety. They are available in all good hardware stores and spare blades can be purchased in a variety of shapes.

A craft knife or scalpel may also be needed on occasion for removing errors from your work.

Sharp scissors are required for cutting around curved edges.

Adhesive tapes

Sellotape can be used for joining sheets of paper together and some other tasks, but masking tape is more useful. This tape is less adhesive than Sellotape, enabling it to be peeled off a surface quite easily. This is especially useful when working on layouts and also for tacking your work to the drawing board when it needs to be held firmly in one position. The alternative in this instance would be drawing board clips – small metal clips which you slip over the edge of the board to 'peg' your work to it. Their use is limited though as small pieces of work which do not

(Fig. 18) Sharpening the nib with an oil stone

reach the edges of the board, and large pieces which exceed the limits of the board, render them useless.

Oilstone

Metal nibs that have become blunt can be sharpened with the use of an Indian Oilstone. They can be obtained from hardware shops in a variety of surfaces from very rough to fairly smooth. A fine oilstone is recommended. The nib is sharpened in the following manner (see Fig. 18). Add a little oil to the stone as a lubricant. Hold the nib at a slight angle to the stone with the front of the nib facing it. Pull the nib across the surface making sure that the whole width of the nib is on the stone. Repeat this several times then once on the back of the nib and lightly on the corners to remove the burr. Make sure that you wash off all the oil afterwards. Do not over-sharpen your nibs or you will find that they actually cut the paper.

Erasers

A soft white rubber should be used for removing writing lines and other pencil marks. The 'Magic Rub 1954' made by Faber Castell is probably the best you can get. W. H. Smith make a soft 'Tablet Eraser' which is more widely available and is quite suitable although the rubber tends to form into long thin strands when used over large areas and this can be a nuisance.

For writing errors and more stubborn marks a harder rubber is required. For small areas pencil rubbers are ideal as the point can be sharpened to a small tip to give accuracy in erasing single letters, spots, etc. The familiar light mauve and orange coloured 'Slick No. 000 Eraser' is a make widely available. If a large area needs to be removed use a piece of fairly hard, abrasive, white rubber as this will be quicker than the pencil rubber. Do not use any sort of coloured rubber as this may stain the surface.

2 Learning the basics

In calligraphy different types of lettering styles are known as 'hands'. The Foundation Hand, sometimes called Roundhand, is the one usually taught to beginners. This chapter explains in detail each stage in forming the letters in the Foundation Hand alphabet and then the natural progression to Compressed Foundation Hand. The first step in learning any new skill is the most important and sometimes the most boring—like learning to play the piano you cannot become proficient unless you practise a great deal. Practise in calligraphy will not only teach you how to form good letters, but your hand will become familiar with the pen and learn more control, your eye will begin to distinguish between good and bad letter formation, and you will become far more appreciative of the written word.

To begin with, fit a size 1½ nib into your pen holder, attaching a reservoir correctly as shown in the previous chapter. With your drawing board prepared and at the correct angle as shown in Fig. 14 (you do not need a guard sheet at this stage) make sure that you are sitting square to the board but relaxed and comfortable, with your eyes about 12-14 inches (30-35cm) from the paper. Have your free hand resting on the board to prevent the paper moving as you write.

The way in which the pen is held is important—hold it with your finger tips about ½-1 inch (1-2.5cm) from the end. Do not hold the pen too tightly as you will prevent your letters having freedom and spontaneity and your hand will begin to ache after a time. Neither should you hold it too loosely or you will not have enough control over the strokes. Fill the pen with ink using the brush. Give it a light shake back into the ink-well to remove any excess ink. With a sheet of cartridge paper on the board, familiarize yourself with the feel of the pen by trying some pen patterns. Try those in Fig. 19 or some of your own. When you feel comfortable with your pen and the ink is flowing smoothly

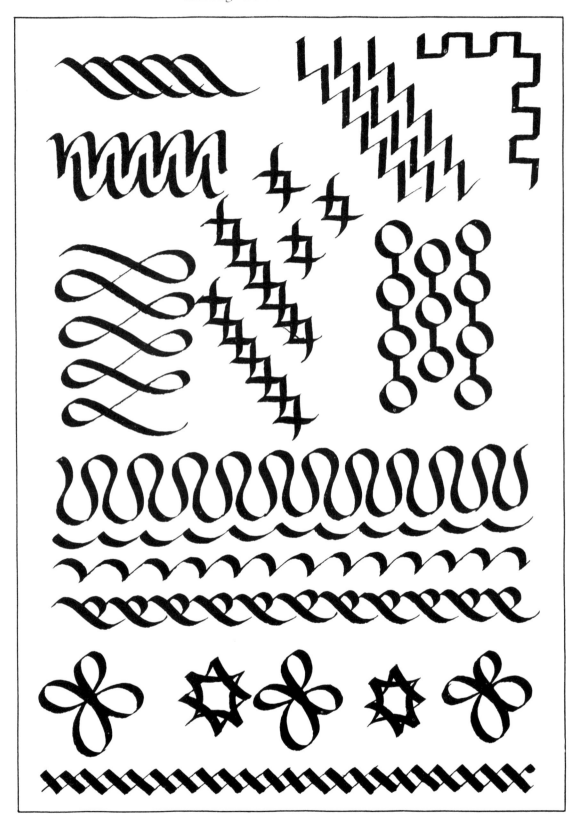

(Fig. 19) Pen patterns

you can rule up a practise sheet and begin to make controlled strokes with the pen.

Ruling up

Before you can rule the writing lines you need to know how far apart they should be. It will help at this stage to know what different parts of the letter are called.

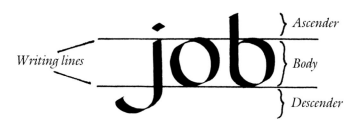

Writing lines — Ascender — Body — Descender

X-height for size 1½ nib

X-height for size 3 nib

X-height for size 5 nib

Whatever nib size you are using, the writing lines, and therefore the body height of the letters, will be 5 times the width of the nib. Make 5 short horizontal strokes with the pen, one above the other.

This is your body height; the distance is referred to as the x-height. If you were using a different sized nib you would work out the x-height in the same way.

The space between the writing lines is twice the x-height to allow room for the ascenders and descenders to be written without overlapping. Rule up a clean page with lines alternately 1 x-height and 2 x-heights apart (Fig. 20). Use a sharp pencil and measure accurately.

Begin by making diagonal strokes, as shown opposite, between the writing lines with the nib held at an angle of 45 degrees to the paper. You will have made the widest stroke possible and the narrowest—the narrow stroke is referred to as a hairline. These strokes should be exactly at right angles. Now change the angle by holding the pen at 30 degrees and repeat the two diagonal strokes. The strokes will still be at right angles but their degree of slope will be different. The 30 degree angle is the correct angle with which to write the Foundation Hand—*not* the 45 degree angle. If you make a cross with the pen held at 30 degrees the vertical stroke will be thicker than the horizontal and this is necessary for the correct formation of the Foundation Hand letters.

Now work through the practise strokes on page 30, keeping the constant 30 degree angle to the pen.

Pen angle correct

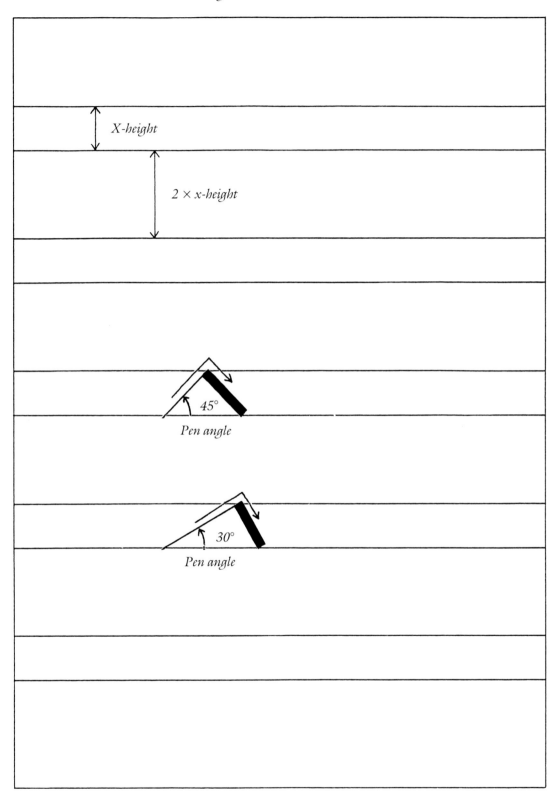

(Fig. 20) Ruling up a page of writing lines

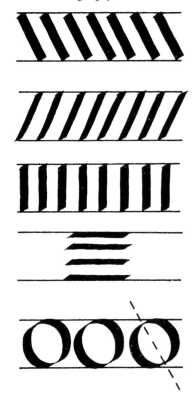

Diagonals — the full width of the pen

Diagonals in opposite direction; if the pen is held at the 30 degree angle these strokes should not be hairline thin

Verticals — keep lines straight and equidistant

Horizontals — parallel to the writing lines

Circles — should be symmetrical when bisected as shown

When you are familiar with the practise strokes you can progress to the Foundation Hand alphabet. This alphabet is based on an 'o' shape. One of the most important things to learn about calligraphy is that all the letters in any particular alphabet have the same characteristics and are as equal as possible, bearing in mind that each letter must look different enough to be recognizable. The round 'o' is the linking characteristic in the Foundation Hand.

The minuscule alphabet

The minuscule or 'lower case' letters are shown in Fig. 21 with arrows indicating the order and direction in which the strokes are made. (The terms 'lower case' and 'upper case' were used by printers because of the drawers in which the type was kept.)

The height of the ascenders and descenders should be 3 nib widths above or below the writing lines. This is not a critical measurement and in time, if you prefer the letters with longer or shorter ascenders and descenders, there is no reason why you cannot make them so. The important thing is that whichever height you settle for, it should be constant throughout the piece of lettering. There is no need to rule in ascender and descender lines, get used to judging the height for yourself.

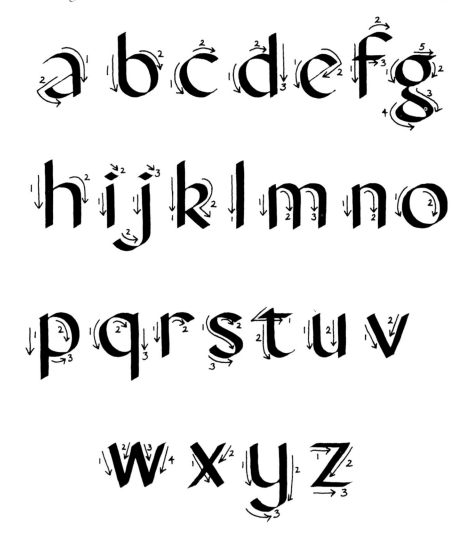

(**Fig. 21**) *Foundation Hand minuscules*

When practising it is useful to group the letters into sets of similar shapes—this will encourage uniformity.

obcdepq

Round letters — all based on the 'o' shape.

fhijklmnr
tuy

Upright letters — note that the 'h', 'm', 'n', 'u' and 'y' all have the same distance between each of the strokes.

SVWXZ

Diagonal stroked letters

Exceptions
Several of the letters require special attention. The first is the 't' which has a special height of its own. Do not make the mistake of writing this letter as tall as the other ascender letters such as 'h', 'k' and 'l', the 't' comes only slightly above the top writing line.

Only the tip of the letter goes above the top line, the horizontal bar runs *underneath* it

The 'g' is a little different from the other round letters because the top circular part is not the full depth of the writing lines.

This circle is 2/3rds of the depth of the lines, the descender of the letter goes down to the same level of the other descenders

The 'z' is the only letter in the alphabet which is made up of a stroke not at the 30 degree angle. The middle stroke is written

z z

with the pen turned flat to the writing line. The reason for this is that the 30 degree stroke is too thin and weak to give the letter a pleasing appearance. Compare the first 'z' written, left, with the pen angle remaining at 30 degrees throughout, to the second letter where the middle stroke is made with the altered nib angle. You can see that the second example is a much stronger letter so the 30 degree rule is broken for this letter only.

The letter 'a' is a mixture of vertical and circular strokes, making it difficult to allocate to a particular group, so practise it separately or make a fourth group with the 't', 'g' and 'z'.

For letters that give you particular trouble, and which seem impossible to get right you can try placing tracing paper over the

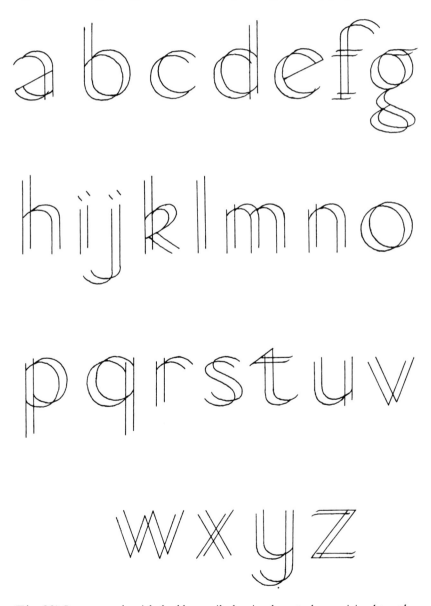

(Fig. 22) Letters made with double pencils showing how strokes are joined together

sample letter on page 31 and carefully writing the letter onto the
paper following the strokes underneath. Do this several times to
help you become accustomed to how the letter is formed, then
go back to your original practise sheet and try it again without
the guide.

A useful exercise is to write the letters with double pencils (see
page 20 for how these are made). You can then see exactly how
each stroke is connected to the next (Fig. 22).

It is worth devoting a lot of time to practising the Foundation
Hand minuscules as they really are the foundation for everything
that follows. The reason a lot of calligraphers fail to ever
produce really good lettering is because they have rushed on to
try new things before the all important foundations have been
laid. Practise letters that give you trouble again and again until
you are writing them well, you can then proceed with
confidence to the next stage—spacing the letters correctly.

Spacing

The eye can read more quickly words in which the letters are
spaced closely together, so ideally you would space all the letters
as near to each other as possible. However, you can see from the
word below where this has been done, that words would not
look evenly spaced and well balanced treated this way. The
middle three letters in the word 'boiling' look very squashed up
whilst there seems to be a lot of space around the first two.

The reason for this is that some letters are more spaced out than
others, or rather they create more space either side of them. The
space created by the letters is represented in the following
diagram by shaded areas.

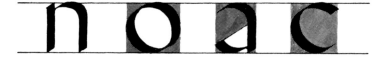

We only need to concern ourselves with the space between the
writing lines when trying to space evenly, as the parts of letters
outside of the lines will automatically take care of themselves if
the inner parts are correctly spaced. Vertical letters occupy no

extra space to either side of them but rounded letters leave space at their corners and open sided letters have even more space joining on from within them. It is therefore necessary to arrange the letters so that they have an equal amount of *space* between them and not equal *distance*.

As you can see there is a very thin strip of space between the 'i' and the 'l' in 'boiling' whereas there is much more between the 'b' and the 'o'. It is therefore necessary to increase the space between the 'i' and the 'l' and also the spaces between other letters that look too close together such as the second 'i' and the 'n'.

Here is the word again correctly spaced. The amount of space between each of the letters has been evened up to make them all look evenly spaced. Good spacing takes a little time to learn, you need to be constantly aware of the amount of space you are leaving between each letter. Once you have mastered the technique you will find yourself automatically spacing correctly without having to think about it.

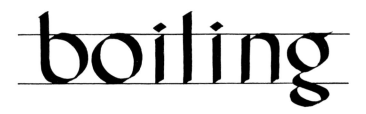

The best way to learn spacing is to begin with the vertical strokes, these are the easiest to space. If the alphabet were comprised of only straight letters spacing would be simple because all the strokes would be the same distance apart. Try this exercise: make 15 vertical strokes of even distance apart.

Connect the strokes together as shown and you have a beautifully spaced word:

You can see from this example how easy it is to space a row of verticals. As straight letters create no space of their own either

side of them they are spaced as far apart as the vertical strokes of letters such as 'm' and 'n'. In this way there is an even amount of space inside as well as either side of the letters. When spacing letters you should always try to achieve this balance of space inside and between the letters. The essence of good calligraphy is this feeling of unity and balance running through your lettering.

The letters with straight strokes are obviously placed the farthest apart. When you come to spacing letters which do not have straight sides you can start with this distance and decide by how much it must be reduced to make it and the space between the previous or next two letters look equal.

When a curved letter meets a straight one (such as the 'o' and 'n' below), if they were placed the same distance apart as two straight stroked letters (such as the 'i' and 'n') you would have more space between the first two because of the extra space at the corners of the curved letter.

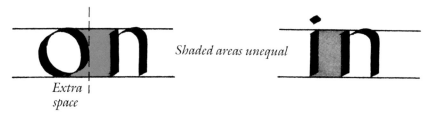

Shaded areas unequal

Extra | space

Decrease this space by bringing the letters closer together, equalling up the space between them and the two straight stroked letters as shown below.

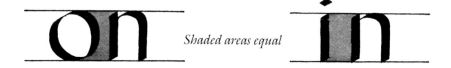

Shaded areas equal

When two curved letters come side by side there is even more space between them if the actual distance is made the same as that between the straight strokes. These, therefore, have to be brought even closer together to equal up the space between them and the two verticals.

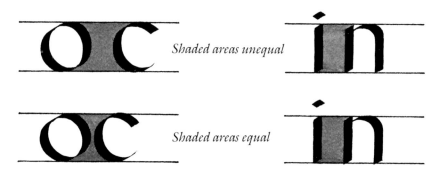

Shaded areas unequal

Shaded areas equal

Practise writing out the following words correctly spaced:

pond	onion	bound
limpid	quill	plum
hound	blind	million

They only contain letters with either straight or rounded sides so you can apply what you have learnt so far about spacing.

It can be summarized as follows:

(a) Two straight strokes together have the widest distance between them (equal to the distance between the two down strokes of an 'n').

(b) A straight stroke next to a rounded stroke has a distance of about half the amount of the two verticals apart.

(c) Two curved strokes have the least space between them. They are as close as possible without actually touching.

Spacing is not quite so straightforward when you come to letters with sides which are neither straight nor curved. These 'open sided' letters, below, each have different amounts of extra space at their sides (shown by shaded areas).

With letters such as these you have to use your judgement to get an even amount of space between each letter. In the following two examples you can see how the space between an open sided letter and a set of verticals is evened up.

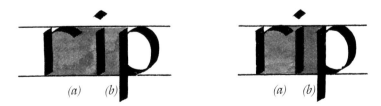

In the first word 'rip' above, areas (a) and (b) are unequal. The 'r' creates so much extra space on its right that it needs to be moved much closer to the 'i' to even up space (a) and space (b). In the second version of 'rip', areas (a) and (b) are more equal in size.

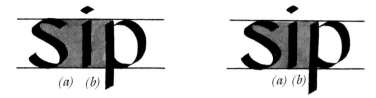

The 's' in 'sip' does not have quite so much extra space on its right as the 'r' did in 'rip' so it does not need to be moved quite so near to the 'i' to make space (a) equal to space (b). Each of the open sided letters has to be considered in this way. You should always be aiming to balance up the amount of space between each letter and the next.

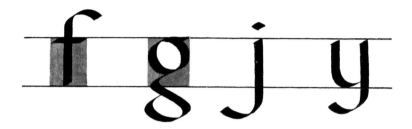

As already mentioned, with ascenders and descenders such as those shown above, it is only the extra space that comes between the writing lines that you need to be aware of to calculate your equal spaces. The 'y' for example could be regarded as a 'u' for spacing purposes or the 'j' as an 'i'.

Having spaced the letters within the words correctly you now need to arrange the words themselves into correctly spaced sentences. The distance between one word and the next should be roughly the width of an 'n' (Fig. 23). Obviously, if one word ends in an open sided letter such as 'e' and the following word begins with another open sided letter such as 's' then the words could be brought slightly closer together to compensate for the extra space created.

If words are spaced too far apart you get what are called 'rivers' running through the page. These are lines of white space that seem to string together through the text.

Common errors and how to avoid them

It can be helpful to the student to see examples of wrongly written letters. Compare them with your own to see if you are committing these errors, albeit unconsciously. It is surprising how many people continue to make the same mistakes, knowing that something is wrong but not sure exactly what it is. It also helps to go back over pages of previous practise to see how you

No nightingale did ever chaunt more welcome notes to weary bands of travellers in some shady haunt among Arabian sands.

*(**Fig. 23**) Word spacing, approximately 'n' distance apart*

have improved. This is not only a good morale booster but will
help you to tell good lettering from bad more quickly.

First check that your pen angle is still correct.

Error	*Reason*	*Correction*
lc	Pen angle too steep causing verticals to be too thin, horizontals too thick and round strokes to be much too thick at top and bottom	lc
fe	Pen angle too shallow causing verticals to be too wide, horizontals too narrow and round letters too 'fat' at the sides	fe
r	Right-hand edge of letter strokes is ragged. Right-hand corner of nib is not touching page. If left-hand edge were ragged it would be the left side corner not touching page	r
c	The letter does not touch the top and bottom lines so making the letter too small. Sometimes it is just the top or just the bottom which isn't reached	c
h	The body of the letter overlaps the writing lines making the letter too large. Train yourself to keep the letters exactly the depth of the lines. Again you might be doing this only at the top or bottom line rather than both	h
d	The top curve of the letter has been made too thin and straight. This second stroke should have been curved downwards before it met the vertical stroke	d

Error	*Reason*	*Correction*
p	The bottom stroke of this letter is missing, having been replaced by an elongated narrow ending to the curved stroke	p
cs	Letters too narrow. They do not conform to the round 'o' shape required of the Foundation Hand	cs
m	The vertical strokes are not of equal distance apart	m
t	The cross stroke of the 't' is above the writing line making it too tall. It should always be below	t
a	The hairline stroke of the 'a' has been made too high causing the letter to be too bulky. The hairline stroke should begin exactly half-way down the vertical stroke	a
h m	The arches have been made too angular. They should be gentle curves	h m
hill	Letters leaning backwards or forward. Concentrate on making upright strokes. If necessary you can draw vertical lines on the practise sheet to get you used to writing upright strokes but it is not advisable to become reliant on vertical guidelines as your letters will lose some of their spontaneity if too restricted	hill
pin		pin
s	Two common errors with the 's'. In the first the top curve is larger than the bottom curve when in fact it should be	

Error	*Reason*	*Correction*
S	slightly smaller. In the second the central stroke has been made too curved in the middle. An 's' is really a straight stroke that just curves around slightly at each end to meet the top and bottom strokes	S

Constant reference to these error checks should bring about the gradual elimination of all faults. Wobbly vertical strokes are not faults but are simply caused by insufficient control over the pen, these will gradually disappear in time with plenty of practise.

The capitals

Also known as majuscules or upper case letters, these are 7 nib widths high which means that they are slightly shorter than the

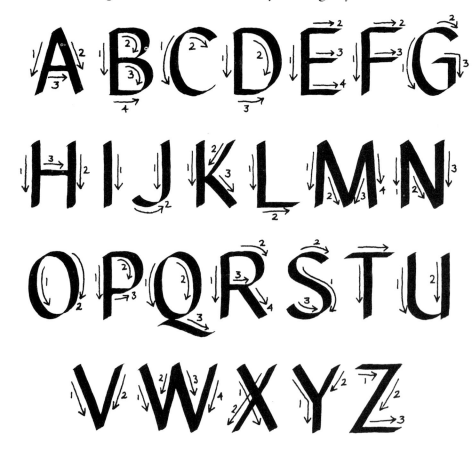

(Fig. 24) Foundation Hand capitals

Ascender height Majuscule height

ascenders of the minuscule letters which are 8 nib widths high. To practise the capitals draw a page of lines spaced 7 nib widths apart. You would not normaly have the top line to guide you with the capital height when you write, you rule only minuscule lines and use your eyes to judge the correct height of the capitals. Practise will accustom your eyes to making the letters the correct height, but to begin with you can write between lines of capital height to familiarize yourself with the look of the letters when written correctly (Fig. 24).

Again it is helpful to group the letters into similar shapes. First practise the predominantly straight stroked letters:

E F H I J L N T U

Secondly the diagonally stroked letters:

A K M S W V X Y Z

Finally the round stroked letters:

C D G O Q B P R

Practise writing minuscules and majuscules together as shown below, keep constantly in mind the relative heights of the capitals, ascenders and descenders. Write between two minuscule lines only (5 nib widths high), no majuscule or ascender lines should be used after the initial practise work unless you are writing capitals on their own.

Aa Bb Cc Dd

Serifs

When the basic shapes have been learnt and can be written competently then serifs can be added. Serifs are the small embellishing strokes used to connect letters together, finish off the ends of strokes, and add to the clarity and style of the letters. There are three different types generally used, the first being a simple curve to begin and end some of the straight strokes:

a m r v

All that is required is the turning of the pen in a gentle curve; the angle of the nib does not alter from 30 degrees, the arm pulls the pen in the necessary direction. Note on letters such as 'm' and 'n' that the feet of the first and second strokes do not have so much of a curve as the final stroke. If they did have, the gaps between the feet would be closed up too much and the letter might be mistaken for a different one or simply become indecipherable.

m r h k

Underlined feet are too curved

The second type of serif starts most of the ascenders and is made up of an additional short hairline stroke to begin the downstroke then a small curve from the hairline blending into the downstroke.

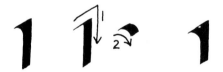

If this curved stroke is not placed correctly you will have a small white space showing in the middle of the three strokes. If this happens you need to make the curved stroke higher up, do not just fill in the white space as your serif will be too large.

 These letters use this type of serif:

bd hil

The third type of serif is used at the foot of the 'f' 'p' and 'q' as shown below and many of the capital letters. It is simply a short horizontal stroke to terminate the downstroke.

Fig. 25 shows the whole of the minuscule alphabet with serifs. As you can see many of them contain more than one type.

abcdefg

hijklmn

opqrstu

vwxyz

(Fig. 25) Foundation Hand minuscules with serifs

The serifs shown are those most frequently used but you can make an alphabet with alternative serifs using the basic letter forms. In the following example three letters are shown with firstly the serif just learnt and then five alternatives. You can in time design your own alphabet with serifs you particularly like, bearing in mind that all the letters of the alphabet should use the

same type of serif and that what fits well on one letter may not be possible on another.

ᑲ ᑳ ᑲ ᑲ ᑲ ᑲ

Ꮒ Ꮒ Ꮒ Ꮒ Ꮒ Ꮒ

ᑭ ᑭ ᑭ ᑭ ᑭ ᑭ

The capital letters can also be given alternative serifs, though generally capitals are not so adaptable as minuscules. The following example shows the first five letters written with three different sorts of serifs. Even with such slight variations as these the three sets of letters each have a different look to them.

A B C D E

A B C D E

A B C D E

As already mentioned, one of the functions of the serif is to link the letters together.

mingling

The final stroke of the letter is continued upwards slightly so that it will run into the next when that is added. This stroke should not be unnecessarily elongated but should just be a natural extension of the letter; if it does not meet the next letter this does not matter, you will still have given the impression of flowing, linked lettering which is what you are trying to achieve. Some of the letters can be joined together to assist spacing. This can also be useful if space is running short at the end of a line. Provided the letters are decipherable there can be no objection to this and it was common practice in Roman lettering from which this hand is derived.

tt ff cr æ œ

Æ VA ꟺ N

Punctuation

A full stop is a simple short diagonal stroke of the pen making a neat diamond shape

A comma is the same stroke but given a curved tail to the left to finish

Colons and semi-colons are these strokes repeated one above the other

Inverted commas sit on a level with the tops of capital letters, slightly below the ascenders

The hyphen is a simple horizontal bar

An exclamation mark is a vertical with the full stop beneath, both strokes being made within the capital letter height

The question mark is made up of three strokes as shown and is also of capital letter height

There are two alternative forms of brackets, either curved or straight. The first type would suit a less formal piece of work. Choose the type that best suits the hand being written and the nature of the piece

An ampersand is a useful symbol, originating from the Latin 'et' meaning 'and'. There are various alternatives, here are two of them

Numerals

Numerals can be written all at the same height, usually capital letter height, or they can be spaced alternately above and below the writing lines. The order and direction of strokes is shown below.

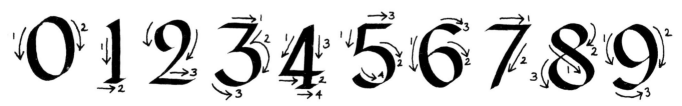

When the numbers are made at alternating heights, the 0 and 1 sit between the lines then the remaining letters alternate above and below. The numeral 0 can be made slightly narrower than the letter 'o' to differentiate between them.

0123456789

You now have all you need to know to write out complete pieces of work. Use the guidelines in Chapter 4 on layout to make attractive pages of lettering and perhaps a simple manuscript book. Do not be over-ambitious to begin with, especially with a manuscript book; if you choose a piece that is too long you will probably find that the writing at the end is far better than that at the beginning, making you dissatisfied with the whole.

Compressed Foundation Hand

When you are happy that your Foundation Hand letters are well formed and spaced you can make the natural progression to compressed writing. You will probably have realized by now that the Foundation Hand that has been learnt takes up a great deal of room. The rounded letters occupy a large amount of space and therefore for the average piece of lettering you will want a more compressed hand.

The most important difference between the ordinary Foundation Hand and the Compressed Foundation Hand is that, whilst the first is based on a circular 'o' the second is based on an eliptical 'o'.

The pen angle remains the same, as does the x-height of 5; all that is different is that the letter is narrower or more 'compressed'. Each letter in the alphabet undergoes the same degree of change, for example:

Creative Calligraphy

Rule a practise sheet in the same way as before with an x-height of 5, still using the 1½ nib. Practise the Compressed letters as shown in Fig. 26.

a b c d e f g h i

j k l m n o p q

r s t u v w x y z

(Fig. 26) Compressed Foundation Hand minuscules

Notice that there is a general uniformity in the width of the letters (obviously letters such as 'm' and 'w' will always be wider and 'i' and 'l' narrower); they are all compressed by the same amount.

The 'e' and the 'a' have undergone a slight change, the sharp angle and hairline strokes have been rounded to make more pleasingly shaped letters, the angles being too tight when compressed to remain as they were.

e e a a

You can use alternate forms of 'a' and 'g' which are better suited to the Compressed Hand and there are also variations to the 'v' 'w' 'x' 'y' and 'z'.

a g v w x y z

You may compress the capitals in the same manner or leave them at the ordinary Foundation Hand width (Fig. 27).

Practise the letters in the same way as before with majuscules and minuscules alternating through the alphabet.

Aa Bb Cc Dd Ee

The Compressed Foundation Hand will probably be the most useful to you. Although you can learn many different and more decorative hands from the following chapter, Compressed

ABCDEFG

HIJKLMNO

PQRSTUV

WXYZ

(Fig. 27) *Compressed Foundation Hand capitals*

Foundation Hand is probably the best choice for documents such as family trees, certificates, etc. It is tidy without being too formal and is suited to many different types of work.

3 Historic lettering styles

Over the centuries a complexity of different shaped letters have been written by many scribes in all parts of the world. The various hands have evolved for many reasons, sometimes the available materials have dictated a style or there was a need for speed, the contemporary happenings demanded particular characteristics, or sometimes it might just have been the creativity of the scribe. In this chapter some of the most popular are shown and described with a little of their historical background.

Uncials

From the fifth to the eighth centuries Uncials were the standard bookhand in Europe. The name Uncial is derived from the Roman word 'uncia' meaning inch; the letters were originally a Roman inch high. There are no separate capital and minuscule letters, they are all one height. Uncials developed from the scripts written in the Roman gospels, missionaries travelling over the countryside spread the Roman hand to new areas. In different parts of Europe particular styles of Uncial writing grew, all with the same origins but acquiring different characteristics. The new hand travelled to the north of England and into Ireland, where lavishly decorated books were written in what became known as the Insular script by monks toiling away in monasteries writing and illustrating the gospels with bold rounded lettering, rich colours and gold, highly stylized animals and people, and elaborate Celtic inter-twining coils. The Lindisfarne Gospels and the Book of Kells are two of the finest examples of Uncial and Half-Uncial script and the illustrations are incredibly complex and beautiful.

In looking at pieces of craftsmanship such as these one gets a strong impression of the slower pace of life in those centuries

which enabled a scribe to spend years and years producing such works. In the present day, when most craftsmen have to concern themselves more with making a living, such time-consuming works of art are rarely possible. The twentieth century emphasis on speed and mass production makes these old manuscripts seem all the more valuable.

The Lindisfarne Gospels are to be found in the British Museum and, along with the many other illuminated manuscript books on display, are well worth a visit. The Book of Kells resides in Ireland, at Trinity College in Dublin. Many colleges, universities, and libraries throughout the United Kingdom and in other countries have collections of manuscripts which the public can see. It is worth looking at these works at first hand to appreciate the colour and detail contained within them.

The Half Uncial with ascenders and descenders gradually developed out of the Uncial script, and by the end of the seventh century a minuscule alphabet had begun to be formed. Uncials were gradually superseded by the 'Carolingian' script.

To make Uncial letters the pen is held at 0 degrees, i.e. with the nib horizontal (Fig. 28). The letters are bold and upright with an x-height of 4. Many have several alternative constructions, although based on the same forms, as the hand was freely adapted by different scribes.

Flat nib angle

X-height

(Fig. 28) *Uncials*

As you can see from letters such as 'n' the pen was sometimes adjusted to construct part of the letter. The thin strokes could not possibly have been made with the pen at the same angle as the thick middle stroke. The medieval scribe did not feel himself

restricted by 'rules' in the construction of the alphabet. It is for this reason that we see so many variations in letterforms in this alphabet. The scribe simply did what best suited himself and the text he was writing. In spite of being a very old hand Uncials have a modern look to them and are becoming more widely used after their long dormancy. They are more suitable for creative work, poems and quotations, small extracts, etc. than for formal work. They do not harmonize well with other hands and are a widely spaced letter, taking up a great deal of room.

A modern Uncial hand based on the original but with the pen at a slight angle is shown in Fig. 29.

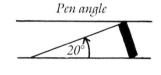

Pen angle

X-height

(**Fig. 29**) *Modern Uncials*

There are various alternative letter forms which can be used. In old manuscripts you can see how scribes distorted the letters for effect and to fill up space.

An Irish Blessing

May the road rise to meet you May the wind be always at your back May the sun shine warm upon your face The rain fall soft upon your fields Until we meet again may God hold you in the hollow of his hand

Uncial lettering (size 10½×12½ inches/26.7×31.6cm)

Carolingian

Europe might have remained divided up into the various little pockets of scribes developing their own particular versions of the Roman hands but for the efforts of one man, The Emperor Charlemagne, King of the Franks and eventual conqueror of almost all of Western Europe. Charlemagne was devoted to Christianity and Roman civilization and was determined to revive throughout his empire learning and culture which had fallen into decline in barbarian Europe. He surrounded himself with learned men from all over the known world; and from England came one of the greatest, Alcuin of York.

Charlemagne founded many new schools and revived the study of history, grammar, theology, and poetry. Classical texts were translated and copied on a large scale, the scribes being required to eradicate past errors which had come about by careless copyists in the previous centuries.

It was from Charlemagne's carefully selected group of men that the Carolingian hand developed. Its discovery is generally attributed to Alcuin of York, for it was he who was directed by Charlemagne to find a hand which could be used uniformly throughout the Empire. Carolingian is a minuscule hand of great beauty, clarity, and simplicity, and it soon became the standard bookhand (see Fig. 30 overleaf). Capitals were required for headings and decorative purposes and for these the scribes went back to the Roman letters, both the formal

'Quadrata' carved into monuments and modified for use in manuscripts and the more informal 'Rustica' letters written with speed in mind (see Fig. 31).

Carolingian is written with an x-height of only three, but it has very long ascenders and descenders going up to 6 nib widths above and below the writing lines (Fig. 30). The angle of the pen is greater than for Uncials, being about 40 degrees.

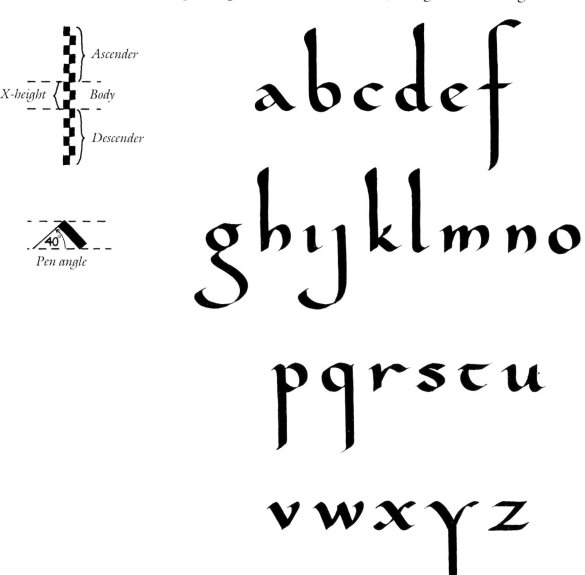

(**Fig. 30**) *Carolingian*

The letters are very rounded and form the basis of many contemporary hands, so their formation was a major step in the history of writing. We had acquired a minuscule alphabet and a model for the future years. Carolingian was at its height from the eighth to tenth centuries.

QUADRATA
RUSTICA

Fig. 31

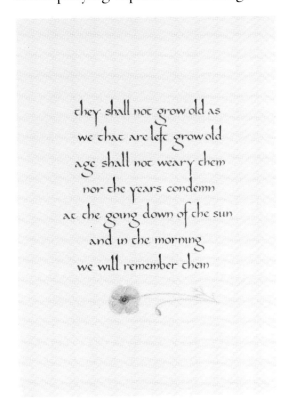

Note that letters such as the 'n', 'm', 'u', and 'w' are made with few lifts of the pen from the page. In the 'n' for example, the pen does one continuous stroke on the paper, only changes of direction form the letter.

The ascenders were given extra strokes at the top, giving them a heavy, clubbed look.

Fig. 31 shows two types of Roman letter which were used as accompanying capitals to Carolingian minuscules.

they shall not grow old as
we that are left grow old
age shall not weary them
nor the years condemn
at the going down of the sun
and in the morning
we will remember them

Carolingian lettering (size 11½×8¼ inches/29.7×21cm)

Because of the large amount of space needed for the ascenders and descenders, Carolingian is not very practical for formal work but it has a very graceful decorative look, useful for informal pieces.

Versals

Versals are capital letters; their name comes from their use as initials at the beginning of verses. They began and were widely used throughout the Middle Ages, were highly decorated, and often filled with pictures. These picture-filled letters are known as historiated initials (see page 60). Versals are a good accompaniment to practically any hand. They are compound letters constructed by building up several strokes together (Fig. 32).

DEFGHIJ

KLMNOP

QRSTUV

WXYZ

(Fig. 32) Versals

The board should be at less of a slope than for other hands. Begin with a No. 4 nib and writing lines ¾ inch (2cm) apart.

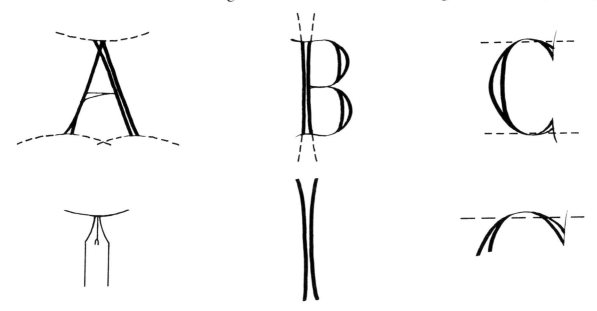

The hairline serifs are made with the pen horizontal. They are made slightly curved as if part of a large circle is touching the edge of the letter

The vertical strokes are tapered at either end, slightly wider at the top. The serifs join them at right angles, not blended in as with roman serifs

The curves of rounded letters extend slightly above and below the writing lines

The letters are filled in with either the pen or a brush as you make them. It is for this reason that the board is at less of a slope as the ink will not then run down to the bottom of the letter: the board can be almost flat or up to an angle of 20°. You can leave

(Fig. 33)

them in 'skeletal' form for particular effect in a piece of work. Versals look their best when used as headings for large complex pieces of work.

Whole words in Versals were often interlocked and joined together (Fig. 33).

A more decorative capital similar to Versals originated in Lombardy and is known as Lombardic. Exaggerated tails and more curved forms give the letters a very decorative, florid look (Fig. 34 and photograph on page 146).

An illuminated poem written in Gothic with interspersed Versals and historiated initial (size 8×13½ inches/20×34cm)

LOMBARDIC

(Fig. 34)

Gothic

Gothic hands were in use at the same time as Versals. Gothic was the bookhand of the twelfth to fifteenth centuries and it was a very angular, upright, and densely packed hand. It was this compressed dense covering of the page which led to the name 'Blackletter' being given to many of the Gothic scripts. The letters grew out of the rounder hands of the previous century; they were gradually angled and compressed to coincide with the fashions of the day—the pointed arches of Gothic architecture, fantastically exaggerated clothing styles, etc. Not only this, but the scarcity and expense of vellum and parchment led to the desire to compress the text into a smaller space. What would have occupied two or three pages in Carolingian lettering could be condensed into only one page in Blackletter. Many variations of the Gothic style were to be found all over Europe. The Italians favoured a more cursive version called Rotunda, while in some areas a flat ended rather than diagonally ended letter was preferred.

Gothic lettering gives us the first quite definite majuscule and minuscule alphabets.

The pen is held at a **30 degree** angle. Gothic Blackletter is basically made up of vertical strokes joined together with a selection of short diagonal strokes:

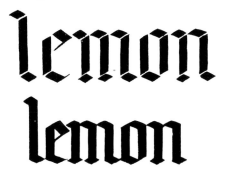

11

Gothic serifs

Rather than the wedge-shaped serif, the ascenders were often given the attractive two pointed or 'Fraktur' serif. This is made with an extra stroke flicked up with the corner of the nib from

the left corner of the main downstroke of the letter. The stroke should be made quickly whilst the ink is still wet.

Blackletter is best written with a slightly smaller x-height than the Foundation Hand; 4-4½ nib widths being suitable (Fig. 35). Although the hand looks complicated, it is usually found to be easier than many others because, as it is very compressed and there are so many verticals, it is much easier to space and there are no circular strokes to worry about. Care must be taken to get the letter strokes and spaces at an even distance apart. The gaps between the writing lines can afford to be much less— as little as one letter height is acceptable.

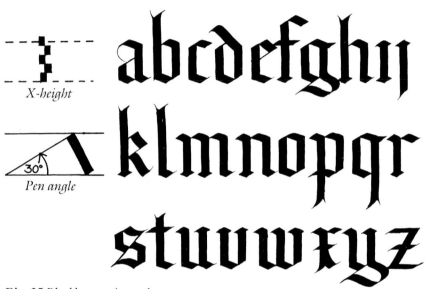

Fig. 35 *Blackletter minuscules*

Here are some alternative letterforms which are particularly useful to differentiate them from other letters in the mass of verticals.

The capitals are highly decorative letters (Fig. 36). The nib has to be held vertically for the thin hairline strokes. There are many different versions of certain letters which you can discover for yourself by looking at medieval examples.

Because of the great number of vertical strokes and the close compression 'Blackletter' is quite a difficult hand to read and this should be borne in mind when designing a piece of work. It is, however, highly decorative, and instantly evokes an historical

ABCDEF GHIJKLM NOPQRST UVWXYZ

(**Fig. 36**) *Blackletter capitals*

feel in most people's minds making it very suitable for pieces where either of these effects is required. The capitals do not look good if used for complete words, as they are far too fussy to combine together well, so it is advisable to use them at the beginning of words only.

Gothic was one of the first hands to be used in printing, which began in the mid fifteenth century. The advent of printing brought about another great change in the course of lettering history and led to the eventual widespread use of Italic.

Italic

When the first printed books began to appear in Germany, Gothic Blackletter was used. Some printers reverted to Carolingian or even Roman when the need for more spacious, legible, lettering was found. As printing became more popular, smaller and cheaper books were needed. A more compressed and economical hand was required and the cursive hand of the

'Humanist' (classical) scribes in Renaissance Italy was used. The type design was based on the 'Cancellaresca Corsiva' or Chancery Cursive of the Papal Chancery.

Italy, where this cursive hand originated, had shunned the hard, angular, Gothic letters, developing its own more cursive versions. In the northern Italian provinces of Florence and Venice scribes were returning to the Carolingian style but with a more compressed, cursive look as the need for speed and economy took over. Out of these efforts emerged the style we now know as Italic. Printing was first done with wooden blocks and the Italic letters were carefully carved into them. When copper plates were introduced the engravers began to make the letters more easily executed with the pointed engraver's tool (burin). Thus Copperplate writing emerged with its elaborate flourishes.

Copperplate

This lettering found such favour that it was to dominate personal handwriting for the next 400 years. It was now the scribes who had to adapt their quills to the printed letter rather than vice versa.

Meanwhile, another invention was underway—paper making (see page 16). Originating in China, it gradually spread and eventually found its way to Europe. By the mid thirteenth century a paper mill had been established at Fabriano in Italy. Paper increased the speed with which printing flourished. By the mid eighteenth century metal nibs began to appear. Many people from different countries are credited with the original idea, but in Britain, Birmingham in particular, the metal nib industry really took off, supplying this and many other countries. Metal nibs were far more practical for the now popular Copperplate writing, as quills needed to be constantly sharpened to provide the fine point required. When machine-made nibs arrived, metal nibs, which for some time as hand-made items had been rather expensive, became available for general use.

And so we have arrived at the tools which the modern calligrapher uses and the lettering style which is most commonly used today. The graceful curving forms of Italic lend themselves to the expression of modern ideas.

The Italic hand has undergone some refinement since its introduction in the fifteenth-sixteenth centuries although retaining the same basic form. The pen is held at a steeper angle than Foundation Hand, 40-45 degrees. The letterforms are

those of the Foundation Hand when compressed, based therefore on an eliptical 'o' but with a slant to the right.

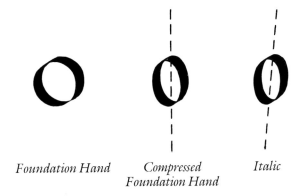

Foundation Hand Compressed Italic
Foundation Hand

A slight angle only is needed, a 5 degree off-vertical slant being most suitable. The x-height is 5 (Fig. 37).

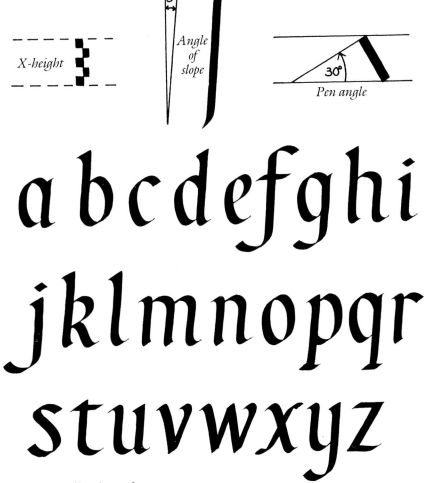

(Fig. 37) *Italic minuscules*

Flag serifs can be used and from these beautiful flourishes can spring.

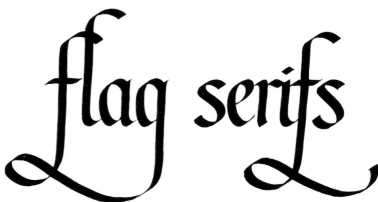

The Italic capitals are basically the Roman type capitals of the Foundation Hand with a slope of 5 degrees to the right (Fig. 38).

ABCDEFG

HIJKLMN

OPQRSTU

VWXYZ

(Fig. 38) Italic capitals

Italic is useful for many purposes. It lends itself to formal documents, combines well with other hands, and can be adapted by the individual to create new and exciting pieces.

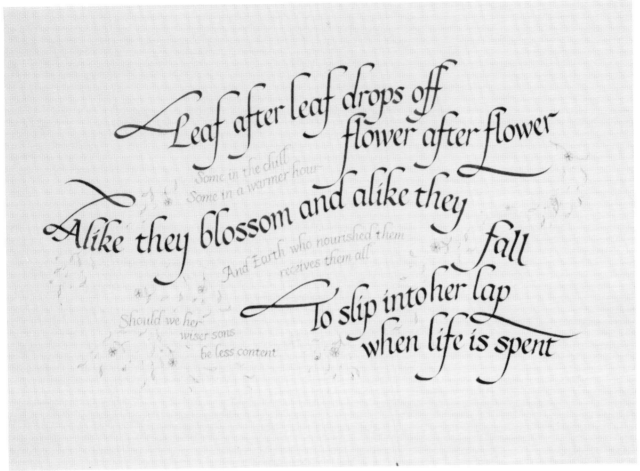

Flourished Italic poem (size 17×11 inches/43×28cm)

4 Layout and design

The arrangement and presentation on the page is as important as the actual lettering of a piece of work. The page should be pleasing and attractive to the reader's eye and when the necessary experience has been acquired, the scribe should try to impart some character and originality to the work. Clarity should also be a prime concern as, however decorative you decide to make the work, you are principally imparting information which is required to be read.

There are many factors which, when combined, make up a good presentation, such as the choice of lettering styles and sizes, their weight and texture, the space around and between the text (i.e. margins, line and paragraph spacing) general shape, and of course colour. The order in which each presents itself for consideration will probably differ with each piece of work, and on most occasions these factors are considered simultaneously so that the piece is viewed as a whole right from the start.

The various elements you need to think about are considered in the following three sub-headings, but as already stated, they should be considered in conjunction with each other. As you become more experienced you will not need the processes to be broken down into more easily understandable stages, but as a basis for the beginner needing guidance they should be helpful.

Margins

The preliminary layout and design of a piece of work is referred to as the rough draft, or simply the 'rough'. When you make a rough of a piece of work the first step is to decide what sort of basic page layout you are going to use. Will it be vertical or horizontal, square, long and narrow, etc. and what size is it to be? (See Fig. 39.)

Vertical

Square

Horizontal

Long and narrow

Margins are required to make the text sit well balanced on the page, and they can be varied to make the design look more interesting. Fig. 40 shows various different arrangements of the margins for a simple text in a vertical block. Normal margins would be proportioned as in the first or second examples in Fig. 40—that is, top and side margins equal with the bottom slightly wider or with the top margin slightly narrower than the sides. A larger bottom margin is necessary as an optical illusion; without it the text would appear to be slipping down the page rather than located centrally. You must use your own judgement to decide the amount of margin there will be. Bear in mind the overall size of the page, the size of the lettering, the width that the writing lines are apart, and the overall shape of the piece. Do not have a tiny piece of text swamped by huge margins: on the other hand avoid margins that are too narrow and make your text look cramped on the page. When you have experimented with simple straight margins you can try some that are shaped such as the final two examples in Fig. 40.

Apart from altering the margins around the text you can alter the text itself. This brings us to another part of the design to

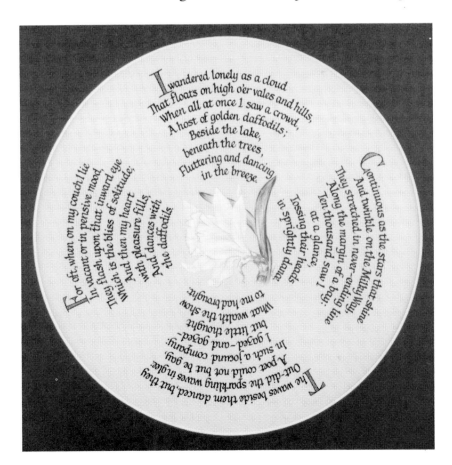

(Fig. 39) *Various page sizes and formats* *Wordsworth's 'The Daffodils' (diameter 8 inches/20.4cm)*

consider, the choice of size, style, and 'texture' of the lettering.

Lettering styles and sizes

The size of the lettering you choose has to be one of the foremost considerations as the whole piece is dependent upon them. Although lettering can be made to fit given proportions, until the actual size or sizes have been determined it is better not to have to work to a specific size; you may be imposing unnecessary restrictions upon your design. The choice of lettering sizes works very much in conjunction with the choice of page sizes and margins. You can experiment by writing parts

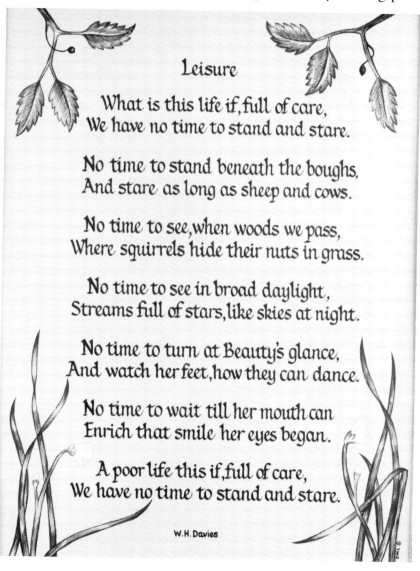

Poem in Compressed Foundation Hand with illustrated borders (size approximately 9½ × 7 inches/24 × 18cm)

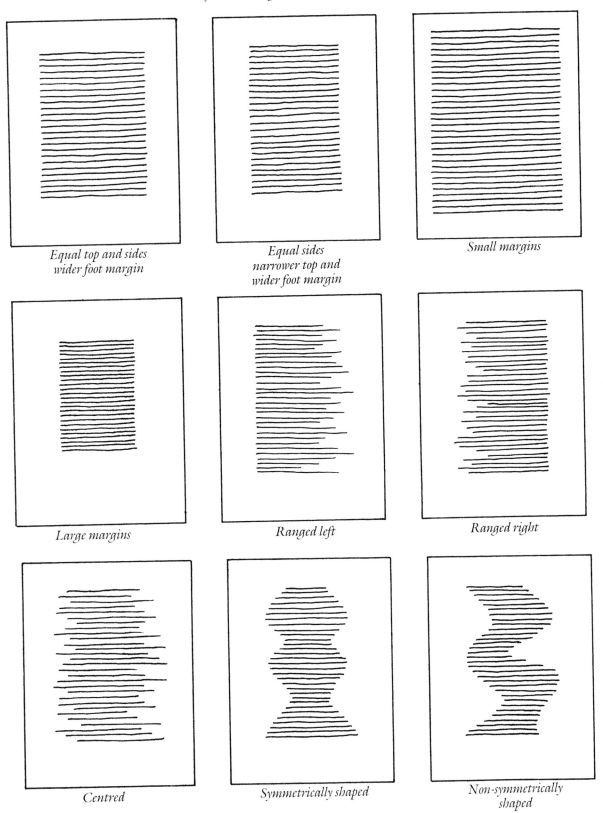

(Fig. 40) *Alternative margins for a simple block of text*

The showers
of the Spring
rouse the
birds and
they sing

The showers of

the Spring rouse

the birds and

they sing

The showers of
the Spring rouse
the birds and
they sing

The showers of

the Spring rouse

the birds and

they sing

(Fig. 41) *Examples of varying texture*

of the text and arranging them about the page. You will see very quickly if a particular nib size is going to make the lettering too bulky or too small for the intended area. Different sizes should be tried and compared until you are sure that you have made the right choice.

Whilst experimenting with your nib sizes you can also try varying the distance of the writing lines. Widely spaced lines in a small nib size look light and airy, whereas larger more closely packed letters have a bold dramatic feel. These elements should be borne in mind when you first read your text. You can then decide which factors are most likely to complement the words.

The lettering itself can be viewed as blocks of texture on a page or, with individual lines (of which many certificates are composed), as strips of pattern. The texture of the lettering depends upon the shape of the letters, their weight, and the line spacing, as mentioned above. In Fig. 41 the same piece of text has been written with different line spacing, size of nib, and letter width, but each is based on the Foundation Hand. They each have a different texture, and it is this overall look of the page which first meets the reader's eye and catches his attention before the individual words are noticed. If you think of all the different variations in texture that you could make with different nib sizes, lettering styles, etc. you will realize what an enormous range of design choices you have for each piece of work.

When you choose the lettering style it should be one which is suited to the subject matter. Some hands suggest particular themes, i.e. Roman lettering with its precise angles and curves indicating order and ceremony, or Italic with its freer, more spontaneous style suggesting creativity and informality. If you want to use a hand based on an historic style think of the original purpose and period in which it was used and see if this ties in with the context of your lettering. The use of Blackletter on a certificate for a scientific establishment would be obviously out of place as would Roman lettering on the menu of a countryside tea shop. You are setting a mood or atmosphere for your reader with your choice of lettering style so do not spoil the effect from the start with a bad choice.

You can choose a combination of several different styles and sizes but it is important, if you mix hands, to choose those that complement each other. Roundhand, for example, would not be a good choice with Uncials as they are both widely spaced, rounded hands. Italic does not combine well with most of the historic hands, therefore it would be better to stick to Foundation Hand as a complementary hand for Italic. When combining different sizes make sure there is sufficient difference in size so that it is obvious that this was what was intended. Very similar sizes can look as if the text was badly written with inconsistent letter heights.

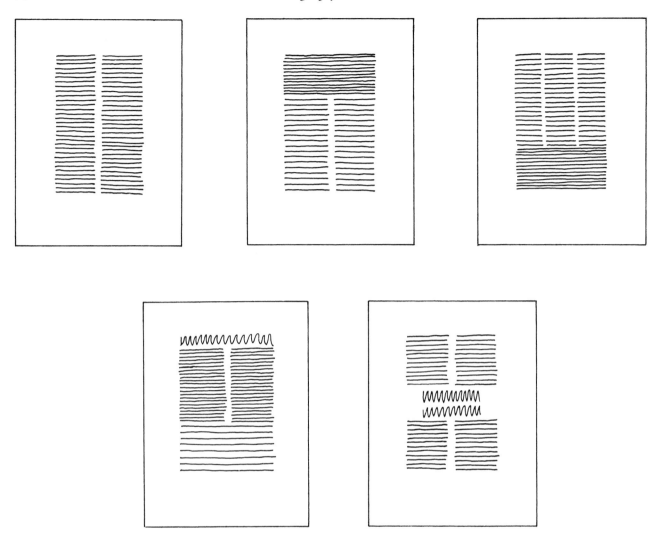

(Fig. 42) *Arranging blocks of text on a page*

You can split the text into columns or arrange blocks of different sizes about the page (Fig. 42). When you add a title this gives you more scope for variety. You should write out the body of the text first and finish with the title so that it can be accurately placed. If the text does not have a title you could perhaps introduce some illuminated initials. This area will be considered further in the next section on colour.

When you are learning, your choice of lettering styles will be limited so proceed in gradual stages with pieces of work within your capabilities. A simple piece well presented is infinitely preferable to a complex work of poor design and execution.

So far we have considered only a plain block of text. If you have verses or paragraphs then you can have fun manoeuvring these to give an interesting and pleasing layout (Fig. 43).

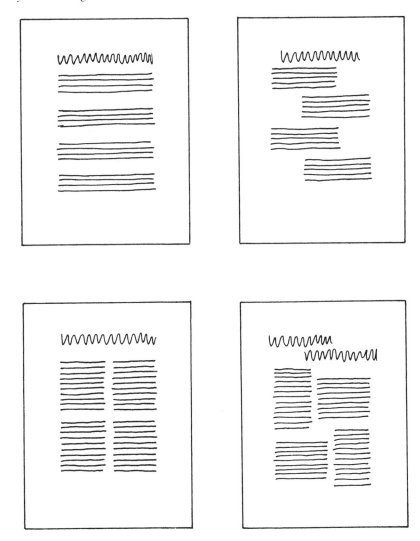

(Fig. 43) *Arranging verses and paragraphs*

Colour

Introducing colour into your work is your final means of adding variety to the design. When choosing the areas to be coloured, aim for a balanced combination of black and colour on the page. A scattering of small areas of colour across the page is not as effective as bold splashes in large areas. As already mentioned in the materials chapter, coloured bottled inks are generally unsuitable for use in a pen. Paint, however, is perfectly acceptable provided it is used in the correct consistency. The colour needs to be fairly fluid but not thin enough to be transparent. The pen will have to be dipped into water and cleaned more frequently than with ink as the paint dries fairly quickly. For some colours, especially red, it may be necessary to

add a few drops of gum arabic to make sure the colour remains fixed to the page. Liquid gum arabic is available in small bottles from most art shops.

Many old manuscripts were illustrated using red only to highlight the pages of black text. This was known as 'rubrication' and it is a very effective form of simple illumination. Apart from red it is best to stick to strong, bright colours such as blue and green. Do not be tempted to combine too many colours on a page, they will have more effect used with discretion. Whole texts in a colour can be tried, though it is wise to avoid large areas in red as this has a very fiery look which can be tiring to the eyes. Remember also that some colours are prone to fading if exposed to strong light for long periods. Many of the bottled inks may fade considerably in a very short time, it is therefore more reliable to use Chinese inks.

You can begin by writing headings or picking out initial letters in colour. Fig. 44 shows several ways in which initials were introduced into the text block. They are usually related in size to the writing lines, being, for example, 2, 3, or 4 lines high. You can elaborate on the simple initials by adding decorative borders. This leads to the consideration of colour for painting areas of illumination and illustrations rather than writing.

When you come to include drawings, a few simple techniques can considerably enhance the work. Flat colour should be used rather than areas of uneven thickness with transparent patches. This occurs if the paint is applied too thinly: however, do not go to the other extreme and apply the paint too thickly, as it will then form ridges from the brushes' hairs which will look unsightly. A happy medium is required and this is a paint with a consistency something like single cream. Keep the colours clear and bright by always using clean water for mixing. The best way of doing this is by having two water pots, one to wash out the brush each time you have finished with a colour and the other kept clear for mixing new colours.

Apply the paint to the surface fairly quickly to prevent ridges of paint drying on top of each other. This first background layer, or base coat, is important as no matter how much detail goes on top, some of the base colour will show through and any unevenness of tone will spoil the overall look. There will be times when you can use uneven texturing for special effects but for simple, straightforward designs flat colour is needed. On illustrations such as badges, logos, etc. the next step will be to outline to give strength and tidiness to the artwork. A fine brush will do for all the curved lines, but for straight lines and geometrical curves ruling pens and compasses can be used for precision. Your work will have a lovely, crisp, sharp finish to it with these tools. For most painting the smallest size brushes can be used, numbers 00, 0, and 1, but for large areas a larger brush

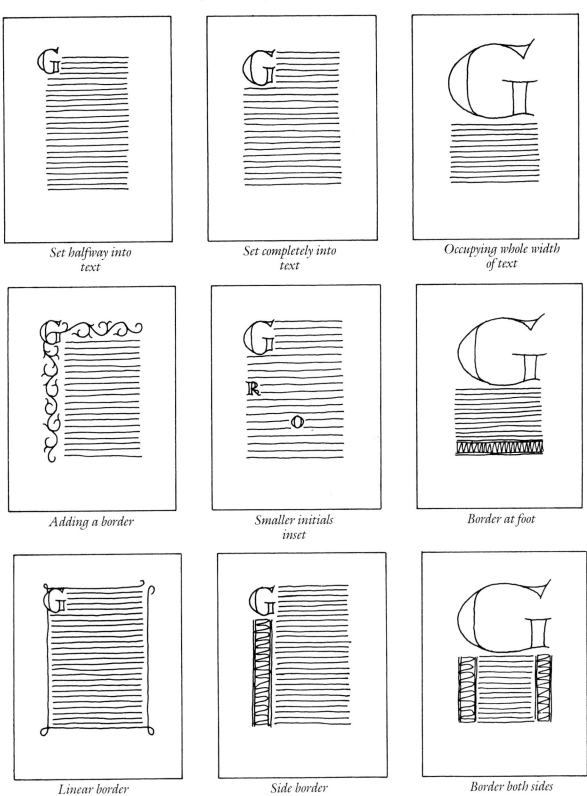

Set halfway into text

Set completely into text

Occupying whole width of text

Adding a border

Smaller initials inset

Border at foot

Linear border

Side border

Border both sides

(*Fig. 44*) *Introducing initials into the text*

MY GARDEN

I've a tiny little garden
'Tis the sweetest one I know
Where the moss-rose and the tulip
and the 'nodding violets' grow

And I love my little garden -
Love it well, although 'tis small -
And I love my floral treasures
But the roses best of all

There's a cosy little arbour
Quite a fairy-like retreat
Where I often watch my roses
and inhale their fragrance sweet

Lovingly I see them open
'Neath the glowing summer sun;
Tenderly I dress and prune them
When the toil of day is done

Wistfully I watch them falling
Leaf by leaf upon the ground
Oh! I'll miss my sweet companions
When the snowflakes fly around!

John W. Bewick
1880

An oval border of flowers is used to illustrate the text (size approximately 18×13 inches/46×33cm)

size such as a 3 or 4 will cover the area more quickly, giving a flat, even surface. When adding the middle and top layers of modelling, i.e. the shading and highlighting that gives a three dimensional look to a shape, take care not to disturb the underneath colour. Very thin paint will be more likely to do this so when applying detail use what is known as dry brushing. With this technique you use a minimum of paint of quite thick consistency on the brush. You can control the application onto the page better and can achieve some delicate effects.

When mixing tints, i.e. pale colours, start with white and gradually add the colour to the required strength or you will find yourself using vast quantities of white to try and lighten the colour. Similarly if you are mixing shades start with the colour and add black gradually.

The initial letters of each verse are used to create a border (size 10×8 inches/25.5×20.5cm)

Manuscript books

Making a manuscript book is a way in which you can learn a lot about layout and design and is a good means of gaining practise in writing whilst producing a finished product. It is fairly easy to cut up a few pages and make a simple informal booklet but for a classically proportioned manuscript book a more detailed approach is required.

The first thing to do is to choose the text. It is better to start with prose rather than poetry. A piece of about 800-1,000 words would make a reasonable length for a first attempt. Decide which 'hand' you are going to use, remembering that you want one which is suitable for the subject matter. The paper is the next consideration.

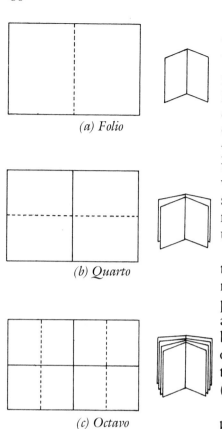

(a) Folio

(b) Quarto

(c) Octavo

(Fig. 45) *Paper foldings*

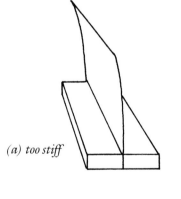

(a) too stiff

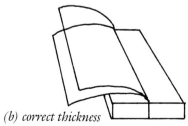

(b) correct thickness

(Fig. 46) *Testing a manuscript book page*

Choosing the paper

The size of the sheets of paper you choose will determine your book size unless you choose to trim them. The sheets will be folded and cut in equal pieces, a sheet that is folded once is known as a folio folding (Fig. 45a): if the paper is cut in half and each sheet folded again (Fig. 45b) it is then a quarto folding. Cutting the sheets into 4 equal pieces and folding them gives you Octavo pages (Fig. 45c). As paper comes in a variety of sizes these foldings will produce different sized pages—depending on which you choose—but quarto foldings will generally give a squarer book page than folio or octavo. If you are using the metric 'A' size papers you will find that whichever folding you use the height and width proportions will always be the same.

Apart from the size of the pages you will also have to consider their thickness. Pages that are too stiff will not lie flat for the reader to see easily (Fig. 46a). You can test the suitability of the paper you wish to use by cutting a piece the intended page size and gripping it between two edges such as strips of wood, books, etc. If the paper stays upright or bends only slightly to one side then it is too thick. Ideally your paper should fall gently to one side and lie flat or fall at least two thirds of the way over (Fig. 46b).

This is particularly important with vellum and parchment pages which vary in thickness a great deal. The smaller the page the thinner your paper will need to be; also a book with many pages will require thinner paper to facilitate opening. For a single section book, which is recommended for a first attempt, paper thickness is not so important and should not give you any binding problems but when you come to planning multi-sectioned books you will need to be aware of the problems your chosen form of binding will give and plan accordingly. A reasonably thick paper is desirable in a book to give the page durability when handled and to avoid problems such as other pages of text showing through but, as has been explained, a page that is too stiff presents its own problems so choose your weight of paper with care.

When making a manuscript book with vellum pages you should not only select skins of suitable thickness but also try and match up similarly coloured skins. The smoother hairside of the skin should always face another hairside, and the reverse fleshside face fleshside (see pages 133-134). If you fold and cut a vellum skin in the same way as a paper sheet this will happen automatically, but if you cut selected pieces from different areas of the skin to avoid blemishes then careful matching is required.

Many papers also need to have sides matching, some machine-made papers in particular have quite pronounced patterns on the reverse side. If this surface is too rough it may not be suitable for use in a manuscript book so try writing on

both sides before choosing a paper. When buying sheets of paper for a book always buy a few extra in case you spoil a sheet and need another which is an exact match.

Book margins

A book needs margins that are in proportion to the page size and that give a clear and pleasing appearance. The margins have several functions: firstly they frame the text, secondly they are an aid to legibility, and thirdly they protect the text from the fingers as the pages are turned.

The margins have to be determined before you can calculate how many words will fit onto a page and therefore how many pages you will need. Two open facing pages, referred to as a double page spread, are considered as one sheet and so the centre margin is made equal to each of the two side margins rather than being twice their width, so that you have three columns of equal width across the open pages. The top margin can be the same width or slightly less than the sides. The bottom or foot margin is twice the width of the top (Fig. 47). You can judge these distances with your eyes (and will probably prefer this method when you have had some experience of writing manuscript books), but there are mathematical methods of calculating margins which are best to start with until you have the confidence to use your own judgement. One of the easiest methods of doing this is explained below.

(Fig. 47) Margin proportions

Calculating proportions

Divide the page height into between 16 and 18 equal parts. Margins based on measurements of 1/16ths of the page will produce wider margins than 1/18ths. You can measure the height with a ruler and divide it into the relevant number of

(Fig. 48) *Accurate method of working out proportions and calculating margins*

parts, but a more accurate means of finding these portions is shown in Fig. 48. Measure the distance from top to bottom of the page and rule a line this length on to a piece of paper. Now draw another line at an angle of about 30 degrees to the first. Make a guess at a distance which you think would be about 1/16th of the page (it does not matter if your guess is not very accurate—any distance will do—but working to scale is easier). Measure your guessed distance along the second line sixteen times from the beginning. Join up the end mark of the 16 to the end of your first line. Place a set square on this line as shown in the diagram then place a ruler underneath the set square. Holding the ruler firmly in place slide the set square along, marking the first line with a small stroke each time the set square meets one of the marks on the second line. Your page height will now be divided into 16 equal parts. Each of these parts is the unit with which you measure the margins of the page. They are proportioned as shown in Fig. 47.

Measure two of the units down from the top of the page and rule in the top margin. Measure four for the bottom and then the three for each of the sides. You will have your centre fold from which to measure 1½ units on either side giving the final measurement. Now that you have the margins you can decide on the lettering size and line spacing for each page.

Lettering size and ruling the page

If you are using the basic Foundation Hand, or another widely

spaced hand such as Uncials, you will want between five and eight words to a line. If using a more compressed hand, such as Compressed Foundation, Italic, or Blackletter, then slightly more words (between eight and ten), will fit onto a line. Experiment on a sheet of paper until you have got a suitable sized lettering. Do this by marking the text width onto your practise sheet and writing a line of text in several different sized nibs.

You can now choose the one you prefer. As you can see from Fig. 49 either example (b) or (c) would be acceptable. Example (a) has too few words to the line and example (d) has too many. Decide how much space you are going to leave between each line of writing, allowing the appropriate amount of room for ascenders and descenders of the particular hand you choose, then mark off the writing lines down the page.

When you reach the bottom margin: if the writing line falls just above that margin, use that writing line as the foot margin—if the writing line falls below the bottom margin you must decide whether you want that set of writing lines or the set above to be the last on the page.

For ruling up the whole book it is helpful to make a paper measure for the writing lines and the margins so that you do not have to measure each page. Just mark off the measurements from the first page onto the edge of a strip of paper (Fig. 50). Use one side of the strip for the vertical and the other for the horizontal measurements. Some scribes use the method used in medieval times of pricking through many sheets with a pin from the marks on the top sheet. Provided you do not mind the pin

(a) Once upon a time in

(b) Once upon a time in a far aw

(c) Once upon a time in a far away country

(d) Once upon a time in a far away country there lived a tiny

*(**Fig. 49**) Determining the nib size for a given page width*

pricks showing on the finished article this is a quick and accurate method.

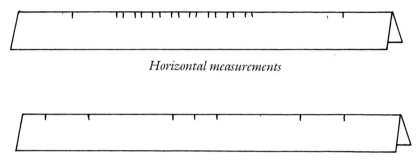

Horizontal measurements

Vertical measurements

(Fig. 50) *Paper measure for ruling pages*

You can calculate roughly how many pages you will need by counting up the number of words in your chosen piece of text then working out how many words will fit onto a page. This will be the number per line multiplied by the amount of lines per page. Divide this number into the total number of words of your text and you will have the amount of pages needed.

e.g. Text of 845 words:

each page has 10 lines of approximately 9 words, therefore 90 words to a page, 845 ÷ 90 = 9.5

9½ pages are needed for the text, but it would be wise to add a page or two as the calculations are fairly rough and whilst a blank page at the end of the book will do no harm, running out of space would be disastrous. In this case allow for 11 pages of text.

You will need a title page and this is always on the recto or right-hand page facing a blank verso (left-hand) page. The opening page of text also faces a blank verso page.

In addition to the pages of text, the title page and blank pages you should have at least two fly leaves (4 sides) at either end of the book (Fig. 51). These greatly enhance the presentation, acting as margins to the whole book. In the case of my example it would be title and blank verso + opening page of text and blank verso + 10 additional text pages + 8 fly leaves = 22 pages. As each folded sheet of paper gives you four sides (or pages) you will need 6 sheets for the book (24 sides or pages). This will give you 2 spare fly leaves which will do no harm.

(Fig. 51) Organization of pages

If quarto pages are used rather than folio pages then only 3 sheets will be needed as each will of course be cut in half. If octavo pages are used then 1½ sheets will be sufficient.

Fold the book pages together. You can now rule up the lines on the text pages. Number each page lightly in the top corner in pencil, this will ensure their use in the right order.

The title page can be centralized on the single side it occupies. Give it the same proportions as the text pages so that there is a feeling of unity throughout the book. If you want to embellish any of the pages with inset initials, borders, and illustrations, these must be taken into account when calculating the number of pages of text. You can design the pages in a similar way to those shown for single sheets but remember that a double page spread is viewed as one whole page. Simple capital letters for new paragraphs throughout the text are a good way of starting. Make the capitals several lines of text high and you can use colour for better effect.

Write out the text first, then put in any embellishments, followed by the title page. If you are using a colophon (signature at the end), add this. When the writing is finished do not rub out the lines, they are part of the book and do not detract from it so need not be removed. The book is now ready for binding.

Binding a single section book

When the pages are all complete place them together in the right order and then between the cover pages. Stronger, thicker paper or card should be used for the cover which is cut to the same size as the rest of the pages. The book is sewn together using strong but fine thread and a strong needle. These and many other bookbinding materials are available from Falkiner Fine Papers (see List of suppliers, page 157). Be sure that the pages are level before placing them in the cover. Divide the length of the book into six equal parts for marking the five sewing holes. If your book is large you may need more than five sewing holes. Mark the five points along the spine and push the needle through each of them so that the sewing holes are shown on the centrefold inside the book (Fig. 52).

Begin sewing from the centre of the book and by taking the needle through the centre point. There is no need to knot the thread, just be careful not to pull it right through. Leave a couple of inches of thread loose inside. Pass the needle through the hold above the centre one then through the top hole. Now go back through the second hole taking care not to pierce the strand of thread already running through that hole. Miss the centre hole and take the thread through the hole under the centre one. Take the thread through the bottom hole then back through the previous one as you did at the top. Finish by going

(Fig. 52) Sewing a single section book

The Company of Fishmongers

The earliest document relating to the fishmongers of London recognises two separate misteries dealing in fish, namely the Pessoners and the 'Stokfysshemongers'. This charter of 10th July 1363, regulates the internal government of the guild as well as the fish-trade in London. It acknowledges the sole right of the Stockfishmongers to trade in dried fish, of which large quantities were imported during the Middle Ages, notably from Iceland. Control of the trade in fresh and salt fish was the prerogative of the Pessoners.

By mutual agreement the two misteries became one body in 1512, and this union, although it is said not to have been confirmed by royal charter until 1536, was marked by a grant of arms to the joint company in the same year.

Azure three dolphins naiant embowed in pale argent, finned, toothed and crowned or, between two pairs of stockfishes in saltire argent, over the mouth of each fish a crown or; on a chief gules three pairs of keys of St. Peter in saltire or.

Crest: Out of a wreath argent and sable two cubit arms, the dexter vested or cuffed azure, the sinister vested azure cuffed or, the hands argent holding an imperial crown proper.

Mantling: Gules doubled argent

Supporters: Dexter a merman armed holding in his right hand a falchion and sustaining with his left hand the helm and timbre, sinister a mermaid holding in her left hand a mirror and supporting the arms with her right hand all proper.

Motto: At worship be to God only.

A double page spread from an illustrated manuscript book on vellum (size 19³⁄₈ × 12¹⁄₂ inches/48.3 × 31.2cm)

back through the centre hole. Cut off the thread a couple of inches from the hole then tie the two ends together over the long centre stitch after pulling the thread tight. Cut off the ends about ¼ inch (7mm) from the knot. The book is now complete.

Multi-sectioned books and those with hard covers involve a lot more work, and if you plan to make a book of this sort then you should seek a good bookbinding guide, with detailed instructions, from your library before proceeding. Alternatively, you can entrust your work to a professional binder as the equipment needed for this sort of work is fairly expensive and requires a reasonable amount of room for storage.

5 Simple projects

Now that you have learnt several lettering styles and gained some knowledge of good design you will no doubt want to put your new skills to some use. You will probably already have experimented with poems and small pieces of prose in your practice work but in this chapter are some of the many simple uses to which you can put calligraphy. They are all things which might be useful in the home or in the local community at some time or another.

Invitations

One of the most likely things you will be able to use calligraphy for is writing party invitations. In fact once people know about your hobby you will probably have relatives and friends asking favours for all sorts of things.

If you undertake to do some invitations do not underestimate the time needed for them. One card may be done fairly quickly but 20-30 will take you all day. If someone gives you a deadline, make sure you can meet it before agreeing to do a set of cards. I once agreed to write a hundred small badges, each with only a single name. The cards were sent to me by courier and were needed urgently by the end of the day. I thought I would have no trouble doing them in a few hours, but by 5.30 pm I was still working. They were eventually ready by 6.45 pm—a far cry from my original estimate! I was lucky in that instance that I had the evening free and that the clients were prepared to wait a few hours longer.

Although it is unlikely that you will be under this sort of pressure unless you are a professional calligrapher, it is worth bearing in mind, especially if somebody offers to pay you for some work.

If you are making party invitations begin by assembling all the information required—see overleaf.

EVENT : ALISON'S 21st BIRTHDAY

DATE & TIME : 9.00 pm , 18th JULY

PLACE : 21 ANGLESEY CLOSE
 ASHFORD , MIDDX.

OTHER INFORMATION : BRING BOTTLE
 R.S.V.P.

(Fig. 53) Cutting card to the envelope size

Decide on the size the invitations are going to be. The usual dimensions are about 4×6 inches (10×15cm) and you will find plenty of envelopes of this size. If you decide on a less conventional size, make sure that you can get suitable envelopes. After going to a lot of trouble to make the cards it would be a shame to spoil the effect with badly fitting envelopes. It is a good idea to choose your envelopes, then cut up sheets of card of the required size to fit them. In this way you also have a larger choice of card to use as paper specialist shops have an enormous range of different coloured and patterned cards that are suitable and would not be found in smaller sheets or ready cut sizes. Make your cards the size of the envelope minus 1/8th inch (3mm) on each side (Fig. 53).

It is best to cut the card with a knife and metal ruler rather than scissors, as you will get a much straighter edge. Always cut a few spare cards in case you spoil any with spelling mistakes or ink blotches. Write out the text roughly, using sizes you think might be suitable, altering them until you find those with which you are happiest. Party invitations can be brightened up with one or two small illustrations. The example shown, being a 21st birthday, obviously calls for a key of the door. Fit the illustration in with the text. The layout arrived at could be as shown in Fig. 54.

Fig. 55 shows some other illustration ideas that could be used.

Once the design is ready the cards need to be carefully ruled with writing lines. Mark where each writing line starts and finishes with the aid of your rough layout; this will guide you as you write. If you are writing in several different colours it is

(Fig. 54) Example of an invitation

(Fig. 55) Decorative devices

quicker to go through the whole set of cards with each one before proceeding with the next colour. You can trace the illustration onto each card after it has been written.

The illustration can be painted in with a small brush or you can actually use the pen to draw the picture. Pen-made drawings can look very attractive and you do not then have the problem of making an illustration that balances the text in strength.

For more formal occasions it may be necessary to have place

(Fig. 56) Linear theme

cards, written menus, or a seating plan. Have a theme running through a set of stationery, matching design and colours (Fig. 56). Linear borders can give a simple but stylish finish.

Change of address cards may be needed at some time. You can add a small house illustration to liven them up or leave them plain and formal (Fig. 57).

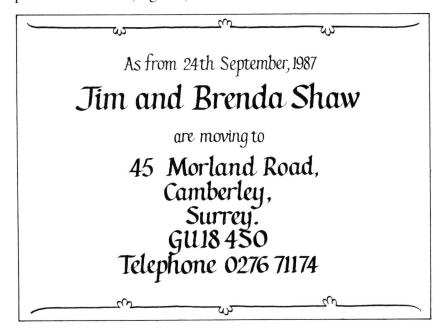

As from 24th September, 1987

Jim and Brenda Shaw

are moving to

45 Morland Road,
Camberley,
Surrey.
GU18 4SO
Telephone 0276 71174

(Fig. 57) A change of address card

As mentioned, there are many cards and papers available with special finishes and you can also buy ready cut cards with deckled borders, windows, etc. which you can use for invitations and other special occasion cards. Craft Creations Ltd (see List of suppliers page 158) have a mail order catalogue of papers, ready cut cards, and envelopes to use for home-made cards. These do, however, usually work out a little more expensive than cutting your own.

Greetings cards

Christmas cards or invitations for a large party might be required in too large a quantity to be hand-written so you could think about having them printed. Printing need not be expensive if you design well. You can make an interesting design with just the standard black ink on a coloured card. The cheapest type of printing is with black ink onto white paper. White or coloured card costs a little more but coloured inks are quite a bit more expensive. As black and white cards would not look very attractive the card colour is obviously the thing to alter rather

than the ink colour if you want to keep the cost down. When your design is ready you can simply have it printed onto the card:

Alternatively you can reverse the printing so that your design is the colour of the card and the black ink is the background:

You can go a stage further and divide the background, counter-changing one part and leaving the other as it is:

You could perhaps, introduce some variations in tone for a section of the card:

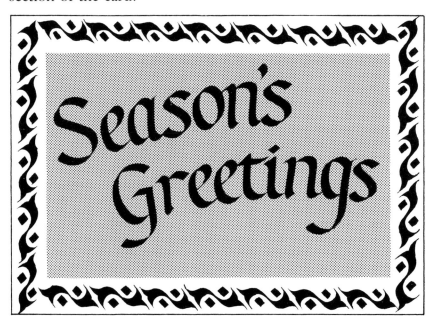

Obviously if cost is not an important factor then you can really go to town with different coloured inks and special types of card. If you have several ink colours you will need to give the printer a separate piece of artwork for the parts to be done in each colour. As the second colour will be printed over the first it is important that they match exactly when overlaid.

High Street printers usually work with A4 sized sheets of paper or card so it is possible to have two separate designs printed on the same sheet or the same design repeated if a very large quantity is required. This will give you folded cards sized 6×4 inches (15×10cm). The printer will cut them for you for a small charge. If you want your cards to be larger you will obviously only get one out of each sheet but they will be trimmed to size for you. You can usually also get them folded at the printers for a small extra charge.

Printing on both sides of the card is usually double the cost even though you may only have a couple of words of greeting to go on the reverse side. A way of getting round this is by dividing the card into three as shown in Fig. 58. By folding the top

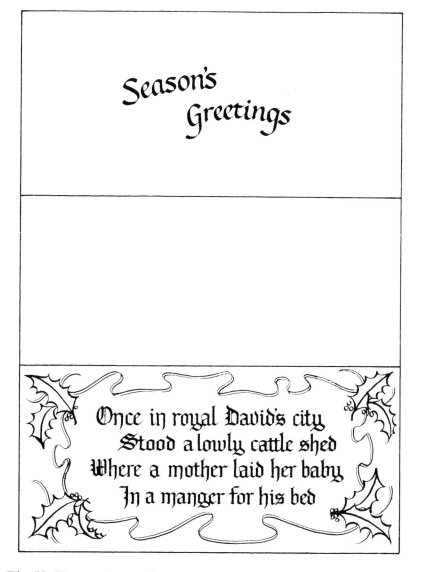

(Fig. 58) How to print a card and fold it to have a message on the inside and just print one side

section under the middle and sticking it down the greeting will appear in the correct place inside the card.

If you decide to have your cards printed in the normal way, i.e. on both sides, make sure you have the greeting (which will be inside the card) the right way round so when the cards are folded over the message is on the right side and the right way up.

Envelopes

An attractively addressed envelope is a pleasure to receive and does not take long to write. You should leave a good margin on the left and at the top (Fig. 59). Begin the first line about a quarter of the width in from the left-hand side and a third of the height down from the top as shown. Step in successive address lines about ½ inch (13mm) each.

H.R.G. Mostyn, Esq.,
13 Fielding Avenue,
Plymstock,
Plymouth.
PL9 4GS

(*Fig. 59*) *Addressing an envelope*

If you have a large number of envelopes to do, rather than measuring up each one separately and ruling the lines you can make a card to fit exactly inside the envelope with the writing lines heavily ruled in black so that they will show through the envelope. Most envelopes are made of paper that is thin enough for the writing lines to show through. You can then write straight onto the envelope with these lines to guide you, thereby avoiding both ruling the lines and the need to rub them out afterwards.

Bookmarks

If you have a spare strip of vellum or parchment why not use it to make a bookmark? A personalized gift is always well received, especially by children. Vellum is very strong and so will last well. Alternatively, use stiff paper or card which can be covered with

(Fig. 61) Shaping the end of the bookmark

sticky backed plastic if required. Use Chinese ink on vellum as paint would be likely to smudge with handling or if the bookmark became damp. Pen patterns can be used to make attractive borders (Fig. 60).

To add a splash of colour you can include a silk tassel. Before writing on the bookmark, shape the ends (Fig. 61) and make a hole with a pair of scissors or a carefully positioned hole puncher.

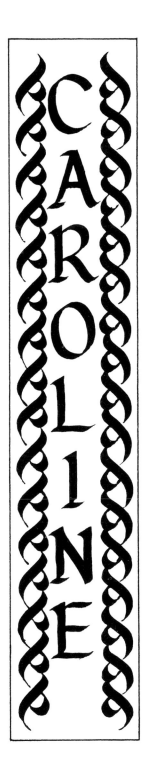

(Fig. 60) Bookmark with a pen patterned border

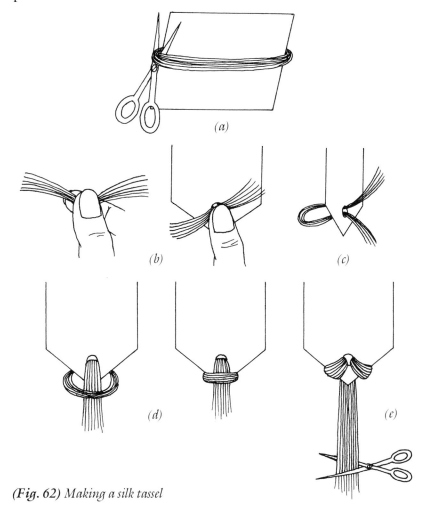

(Fig. 62) Making a silk tassel

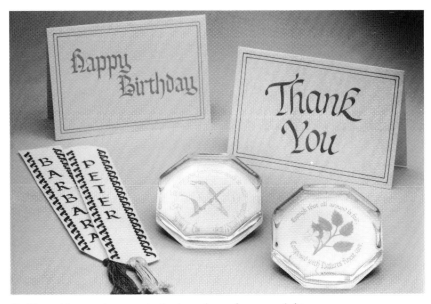

Calligraphic greetings cards, bookmarks and paperweights

Proceed with the writing then make the tassel as shown in Fig. 62, using silk embroidery thread which can be purchased in a vast array of colours from haberdashery shops.

Wind the silk around a piece of card about 3 inches wide (Fig. 62a); cut through one end and hold the pieces together in the middle (Fig. 62b); push the centre part of the threads through the hole in the bookmark (Fig. 62c). When you have a loop of threads on the other side, pass the ends under the tip of the bookmark and through the loop (Fig. 62d); pull the ends carefully so that the loop tightens up. Trim uneven ends of the tassel for a neat appearance (Fig. 62e).

Paperweights

Blank, recessed paperweights complete with backing are available by post from Ralph Green of Leeds (see List of suppliers, page 158). They can be purchased singly in a variety of different shapes and sizes. You simply write or paint your design on any sort of paper, carefully measured to the correct

(Fig. 63) Making a paperweight

Glass

Design

Backing

(Fig. 64)

(Fig. 65)

(Fig. 66)

size for the paperweight, then use the adhesive backing supplied to stick the design in place (Fig. 63).

Small poems or quotations with little illustrations included can be written to fit paperweights. Gold paint or powder looks very effective shining through the glass. You can also buy gift boxes for the paperweights, making them good ideas for presents.

Bookplates

A bookplate is a much better way of identifying your books than a name scribbled in the corner. You can design one for yourself or give some as a present to a friend. Combine your favourite hobby, plants, animals, etc. into the background design with your name and 'From the Library of', or the latin 'Ex Libris', or simply 'This book belongs to' (Figs. 64-66). You can have your design printed on gummed paper at most High Street printers, although they can usually only provide white paper. A more distinctive look is obtained by using Conqueror Laid Paper which is available in various colours. As this paper is not gummed, bookplates made with it will need to be stuck into the book with glue. It is a good idea to do the design larger than you actually want it then have it reduced; the whole design will then be sharper.

Posters and notices

The important thing to remember with posters is to keep them simple and uncluttered. A page of densely packed information is not likely to make someone want to read it as they quickly pass by. A few clear, to-the-point statements, telling the reader

quickly what he wants to know is far more effective. The important details such as the event, the date it is to be held, and the place, should be large, clear, and eyecatching enough to make the reader want to continue on to the smaller details.

Poster pens are available in fairly large sizes, but if you cannot find a pen large enough for a specific piece of work, adequate pens can be made from a variety of odds and ends. A thin block of wood or a piece of plastic with some cloth fastened over it to hold the ink will do. Your letters will obviously not have the same accuracy as those written with conventional nibs, but on a large scale this is not so important and the effect should still be pleasing.

As most posters are intended to be displayed outside it is an advantage if they are waterproof. Acrylic paints are useful here in that they are thinned and mixed with water but waterproof when dry. There are various types of acrylic paint on the market now, some are available in tubes and are used in the same way as gouache—though the consistency tends to be thicker, which can cause problems. There are now also liquid acrylic colours available in bottles. These are transparent unless mixed with white, but they are easier to write with than the thicker tube colours.

Wine and jam labels

A calligraphic label adds a touch of class to home-made wine and preserves. Fig. 67 shows some ideas as starting points for your

(Fig. 67) Labels

own designs. If you need a large quantity you can photocopy your background design then write in the name and date on each one as you use it. Photocopying can be done on coloured paper so this is a very cheap method of livening up your produce.

Personalized stationery

You can design your own or family notepaper with a distinctive calligraphic script. A High Street printer will supply you with any quantity of printed sheets from your own artwork, with matching envelopes, much more cheaply than the kind you can order with type-written headings. Again Conqueror Laid paper is the most suitable and you usually have the choice of at least a dozen colours. A4 size sheets will be supplied and you need size DL envelopes to go with them. If you prefer smaller sheets then you can have the paper cut in half, giving A5 size sheets. This of course means that your design can be printed twice on each sheet before it is cut, giving you twice the quantity for the same price. Alternatively you can leave one half blank so that you can use these pieces as continuation sheets. If you do have the heading printed twice on each sheet a small charge may be made for duplicating the design before the sheets can be printed. The envelopes to go with A5 paper are size C6.

Fig. 68 (overleaf) shows various ways in which you could set out the same information.

You may at some time want to design business stationery for yourself or another person. A logo often needs to be incorporated and the same design can be adapted for use with a whole range of business stationery, as shown in Fig. 69 overleaf. Full A4 sheets are usually used but sometimes only two thirds of the sheet is used for headed paper by cutting off the bottom third, this gives a squarer page. The remaining portion is then used for compliment slips.

Maps

Maps have been made over the years that are extremely complex and beautiful. They were used in early medieval times more as a means of decoratively relating historical information and learning than as documents to be used geographically. Less attention was paid to the correct location of places and more to illustrating them with pictures of animals, people, and stories connected with the different areas. However, in the fourteenth and fifteenth centuries—as people began to acquire more knowledge of larger areas, and with wider travel and greater

John Smith
20 Wilton Avenue
Parkmead
Chester

20 Wilton Avenue, Parkmead, Chester
John Smith

John
Smith

20 Wilton Avenue
Parkmead
Chester

John Smith
20 Wilton Avenue, Parkmead, Chester

(Fig. 68) Various options for headed notepaper

(Fig. 69) Business stationery

exploration overseas—more accurate maps were needed, with emphasis on coastlines in particular. By the sixteenth century maps were no longer pictorial but accurate charts based on observation and measurement. Twentieth century maps are, for the most part, devoid of pictorial decoration, so it is an enjoyable exercise to make one for yourself.

Your map need not be very grand or complex, you can make a simple map of your own town or village with just a pen drawing to accompany the calligraphic names. You can even make practical use of it by sending out photocopies to any visitors needing to find their way to your home. Later when you have gained some experience you can embark on a more decorative large-scale map of an area which you have visited, or one which particularly interests you. Special features can be picked out with small illustrations and you will probably find by investigating the area that there are a number of interesting things connected with it that you can use as decoration. For example, many towns have a coat of arms which can be incorporated into the picture; you might find that some historical event of significance occurred in the locality or that there is an old fable about the place, such as the Loch Ness Monster or the witch of Wookey Hole.

For the time being we shall only concentrate on a simple map of your own area. It is best to actually work from a local map so that you get the scale and location of places correct. For street maps in built up areas a good approach is to blow up a large-scale map with an enlarging photocopier (this service is provided by many printers). Trace off the parts you wish to include. You can omit parts which do not contribute greatly to the appearance and usefulness of the map, such as small side roads. With the basic structure of the area outlined you can make the map more artistic, picking out features such as churches, areas of grassland, trees, etc. These can all be drawn in with the pen as in the example in Fig. 70 where the drawings combine nicely with the lettering, or you can be a little more accurate and realistic with painted brushwork and colours.

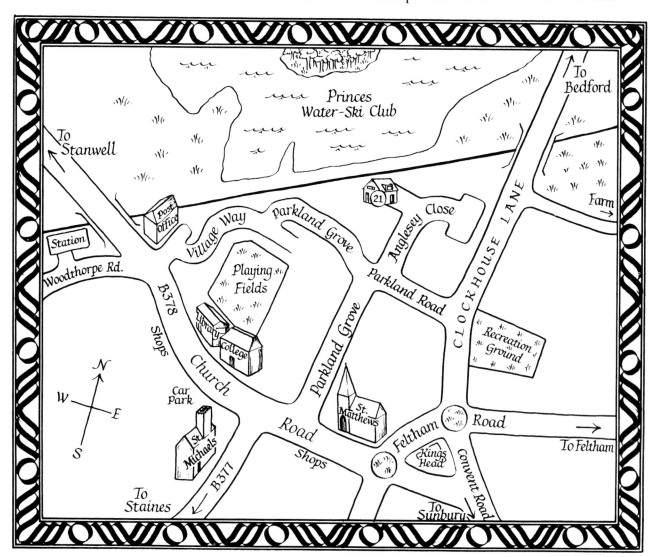

(Fig. 70) An example of how you might set out a map

The place names will, in most cases, have to be written around curving roads without the aid of writing lines. You will probably find that this is easier than you think if you have practised well. The whole piece can be finished off with a decorative calligraphic border. You can refer to the pen patterns you did in Chapter 2 for ideas.

Handwriting

Apart from using calligraphy to make decorative pieces of work, you can use it to make your own handwriting more pleasing and probably more legible. Indeed it would seem like an obvious thing to do, making continual use of your skill, and yet many calligraphers do not make a conscious effort to improve their handwriting but rather consider it as something quite separate from calligraphy. One of the reasons for this is probably that writing with an edged pen and concentrating on making uniform letters is much slower than normal handwriting. It is easy enough to assume that you do not have time to write your day-to-day jottings and correspondence in this way. Not only this, but some people think that by writing calligraphically their handwriting will lose its originality and uniqueness.

There is, however, a type of lettering which strikes a balance between calligraphic lettering and ordinary handwriting. Cursive Italic letters are designed with speed in mind; they have ligatures connecting many strokes so that the pen needs to be lifted from the paper less frequently. The letters also have an economy of stroke which promotes speed. You will find after using this hand for a while for your daily writing that it quickly assumes a character of its own, so that you have retained your individuality. This will also happen in time with your formal calligraphy, but the acquisition of originality takes longer because you are striving to make your letters conform to the models which you are copying.

The fountain pen which was not recommended for any writing which required finesse and accuracy, now comes into its own. It is a much more practical tool for everyday writing, being easy to pick up and put down and not needing constant refilling.

Fig. 71, overleaf, shows a cursive Italic for you to try and from which you can sort out your own 'everyday' hand with the characteristics you most enjoy writing and which are most likely to give you speed and fluidity. Do not bother with writing lines—letters and other household notes do not need the formality of completely straight lines and this will enable your lettering to develop with freedom and originality.

Having used calligraphy for some of the small projects shown in this chapter you should now feel confident to try something a

abcdefghijklmn

opqrstuvwxyz

(Fig. 71) *Cursive Italic*

little more adventurous. The following three chapters are concerned with more complex pieces of work. For some, further equipment and materials are necessary, and they are explained in detail as they arise.

6 A family tree

Most people, at some time in their lives, take an interest in their family history: genealogy is now a rapidly expanding hobby. When I exhibit my work at Craft Fairs there is always a knot of

Illustrated family tree (size approximately 21×27½ inches/54×70cm)

people around the family tree displayed—even though it is not their own it provokes interest.

If you or a friend have a family tree already researched, and you wish it to be displayed properly, you now have the means to set out your information in a decorative way. Calligraphy is excellent for family trees, giving a smart, clear chart if well executed. Even without research material it is very easy to put together a plan of all your relations. Most families, when asked, love to talk about past and present relatives and are only too happy to fill in gaps. You would be surprised at the rate at which your information will grow, and even a simple 5 or 6 generation chart will make a fair sized piece of work worth displaying.

Novices seem to encounter enormous problems when setting out lists of names, so I shall explain how to achieve a good layout in detailed steps. Clarity is so important to prevent the relationships becoming muddled and meaningless. When your research is complete you will probably have a fairly jumbled sheet of information, as you have altered and added material as you progressed, so your first job is to set out a more comprehensible chart.

Assembling the chart

When setting out information, follow the guide below and you will find that the tree fits together easily. In genealogy an = sign is used to denote marriage. From this sign descends the line from which children are entered on the chart, i.e:

The children would in turn have their spouses and children entered in the same way:

Second marriages can be entered with an = sign on the other side of a name:

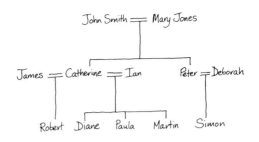

Various layouts have been devised to make family tree recording clear and concise, but the above method is from a calligraphic point of view the most straightforward.

It is very important that all members of a particular generation are placed on the same horizontal level across the sheet. Look at the diagrams (Figs. 72 and 73) for an example of how

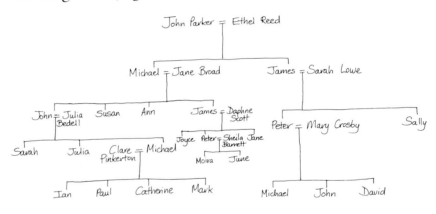

(Fig. 72) Tree plotted with generations wrongly aligned

Note the group of three generations in the centre which have been cramped together, and the three sons on the bottom right who appear to be cousins of the other four bottom row names

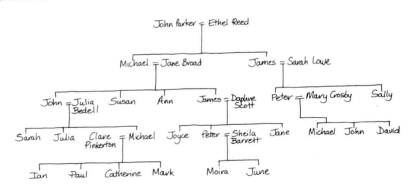

(Fig. 73) Generations correctly aligned

The cramped central group has now been correctly lined up with the other generations and it can now be clearly seen that the three sons of the previous diagram are of an earlier generation than they appeared making them uncles to those in the bottom generation rather than cousins

generations are mis-placed and how to rectify the layout. Only when you have all the generations organized into their correct rows should you proceed with drawing up the tree.

Decide what sort of lettering style you want to use. Remember—clarity is the all important factor and therefore a plain, simple hand is the best. Gothic Blackletter can look very decorative and give an historical feel, but because of its illegibility it is not a wise choice. Italic, to my mind, does not look 'right', the slope of the letters not tying-in with the formal layout. Uncial would be too bulky. Ordinary Compressed Foundation Hand is therefore recommended. The size of nibs you intend to use should be chosen next. A larger size can be used for names, and a smaller nib for other information, such as dates of birth, marriage, death, occupation, etc. For most family trees you will find a No. 4 nib suitable for the names and a No. 5 for other lettering. If your tree is very large it may be necessary to use smaller sizes to prevent the tree from having massive dimensions. Alternatively, if you do not have a great deal of information, you might wish to increase its size by using larger nibs.

You will need a good quality paper such as 'Canson Mi-Tientes' or 'Fabriano Ingres' for the finished piece. These papers, being fairly thick, can stand up to the removal of letters if necessary. With all those names and dates to be entered, a few mistakes are likely to be made. Several sheets of thin layout paper, scissors, masking tape and Sellotape are needed for the rough. For the finished piece you will also need some red paint for the lines, any colour would do but red is a good contrast and the traditional accompaniment. A ruling pen is essential as you want your lines to be neat and straight.

The layout

First count the number of generations and decide how much space you are going to allow for each one. If there are not many generations and the tree is fairly wide then to balance, leave quite a lot of space between each generation. If your tree is tall and narrow then you will need to bring the generations closer together. Make sure that you leave enough room to fit in all the biographical information belonging to each person without having to cramp the writing together, somewhere between approximately 5cm (2 inches) and 7cm (2¾ inches) would suit the average tree. Allow another approximately 6cm (2¼ inches) for the title and approximately 2cm (¾ inch) at the top and bottom for a border, and you have the height of the whole piece. The tree in Fig. 73 for example (previous page), has 5 generations, so allowing approximately 6cm (2¼ inches) for the

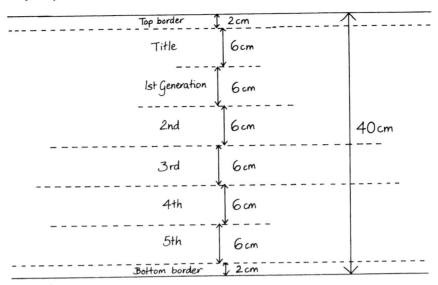

(Fig. 74) Calculating the height of the tree

title and approximately 4cm (1½ inches) for the borders the tree will be approximately 40cm (15inches) in height (Fig. 74).

The next step is to count the number of persons in each generation and find which has the most. The largest generation will determine the width of the whole piece. Now decide how much space you can afford to leave between each name; to prevent a cramped appearance a good guide is 1½-2½ inches (4-6cm) apart. This could however make the tree too wide, in which case decrease the space but bear in mind that less than 1⅜ inches (3.5cm) would be too close and names would start overlapping. Find the best compromise for your particular piece of work. In our example the 4th generation has the most names (11) so it is this one which will determine the width. Allowing 2 inches (5cm) for each name (making sure that there is a 2 inch (5cm) gap at the side of each of the end names too), and ¾ inch (2cm) either side for the borders gives the tree a width of 25½ inches (64cm) (Fig. 75).

At this point you should also bear in mind any illustrations

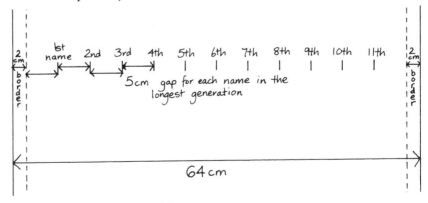

(Fig. 75) Calculating the width

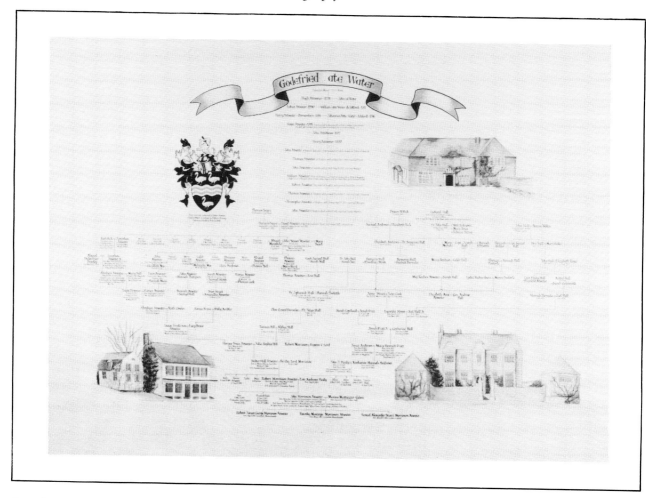

Family tree (size approximately 6×4 feet 180×120cm)

that you want to include. It is probably best to keep it simple on your first attempt, but if you do want illustrations you will need space for them. It is advisable to plot the whole tree first and see where there are gaps into which illustrations can be fitted. If no suitable gaps occur naturally the text can be slightly rearranged to fit in illustrations where you want them. It is better to keep the illustrations out of the main body of the tree, corners are usually most suitable as shown above.

The type of illustrations usually added to family trees are coats of arms, pictures of towns or houses mentioned, illustrations of occupations of the family members, etc.

You are now ready to start plotting out the tree on layout paper. Tape together enough sheets on which to fit the whole tree. Mark off down the page the number of generations with the correct distance between them, then lightly rule straight lines across the whole sheet so that you have a line marked for each generation (Fig. 76). Work with your largest generation, making sure you have the right line on the layout sheet. Rule a

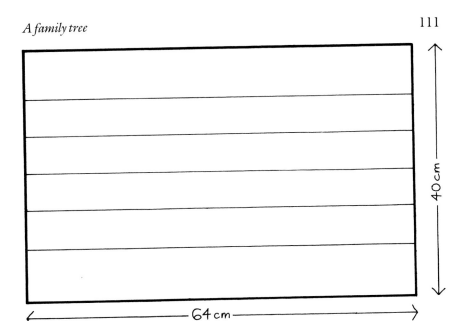

(Fig. 76) Ruling generation lines

vertical line down the centre of the sheet to use as an axis on which to centre all the information.

Find the middle name from the largest generation; this will come on the centre of the line where the vertical crosses the horizontal. (Where there is an even number of names the middle two will be spaced equally either side of the centre line.) Measure out to either side the number of spaces for names, then mark each point with the initials of the person to be entered there. Rule heavy lines over the previous light line to join together families of brothers and sisters (Fig. 77). Gaps will be left where each family stops and the next starts and where husbands and wives are entered. When this generation is

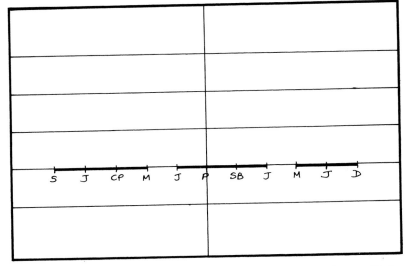

(Fig. 77) Plotting a generation (the lines are shown thicker than they need be here and in Fig. 78 to illustrate the method used)

completed, move on to the one above or below; fit in the names trying to keep spacing equal throughout each line. Add the marriage signs (=) and the vertical lines connecting families.

Sometimes things fall into place without any trouble, on other occasions a certain amount of juggling is needed to find the best layout. Remember that what you are trying to achieve is the clearest possible arrangement of the information. Fig. 78 shows the whole tree plotted out: note that generations 1 and 2 have been slightly widened for better effect and that where the offspring at the right of lines 3 and 4 did not come directly below their parents the connecting lines were brought across to meet them.

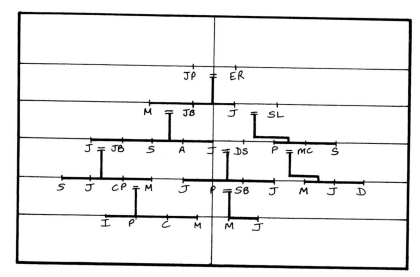

(Fig. 78) A completely plotted tree

This example is of a fairly small, simple tree but most trees are much larger and more complicated. Many families have inter-marriage and divorces to be represented, which can greatly complicate things. If you find that one line crosses another, to avoid confusion to the reader you should make little bridges where the lines cross, as this makes each line easier to follow (Fig. 79). When you have the whole tree plotted you are ready to write the names in rough. The reason for writing all the information in rough beforehand is firstly that you can make sure it will fit into the space provided, and secondly that you can centre each name and its information under its mark. This would never be possible if the names were written straight onto the final piece.

Use a sheet of cartridge paper and rule up sets of lines the correct height for the nib you are using, i.e. if you are using a No. 4 nib then the lines will be approximately ⅙ inch (4mm) apart. Most names, especially for the largest generation where names will be closer together, will have to be written on two

lines or even three if there are two forenames. When all names in the large size nib have been written, rule lines underneath for the rows of small lettering (Fig. 80). As there are usually different amounts of information for each name this can be a fiddly process, but it is well worth the trouble when your finished piece has well spaced lettering.

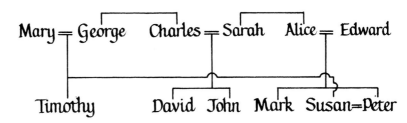

(Fig. 79) Bridging overlapping generations

(Fig. 80) Spacing the small lettering well

When you have written out all the names, cut them out and stick them in their correct places on the layout sheet. The best way to do this is by using masking tape. Cut small pieces of masking tape and roll each piece into a loop with the sticky side out. Stick to the back of each name and press into its place on the layout. The advantage of using masking tape is that it can be easily peeled off and re-positioned if it is not quite right, or if you decide to alter the layout. When cutting and sticking is complete, look over the whole piece. Obviously it will not be symmetrical, some branches of the family being much larger than others, but is the general effect pleasing? Is there a good balance on either side? Are there large gaps? You can at this point shift names across to give a better balance (Fig. 81). When you are satisfied with the layout you can add the title. A large nib will be needed for this, probably a size No. 2 or 1½. Write out the title, centre it at the top of the layout and fix into place with masking tape. If illustrations are to be included, make rough sketches to size and fix them into position on the layout.

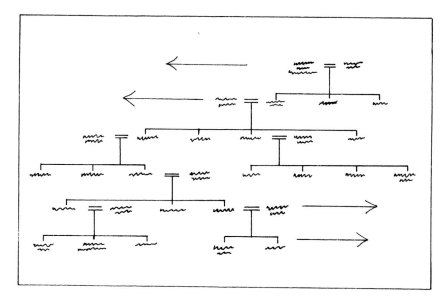

(a) There are gaps in the top left and bottom right corners, these can easily be avoided without altering any of the relationships by simply sliding some of the generations across in the directions indicated

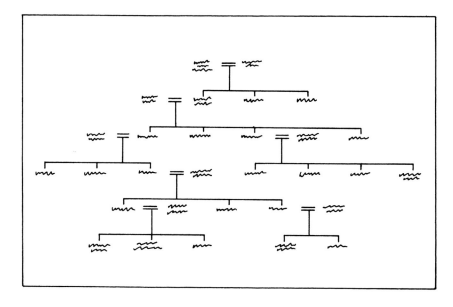

(b) A much more symmetrical layout has now been achieved

(Fig. 81) *Altering layout for better balance*

With the layout complete you can now begin the finished piece.

The finished work

Select the paper you are going to use and cut it to size. Leave good margins on all sides, these can be trimmed later. During handling the edges of the paper are quite likely to become a little

tatty and will benefit from a trim.

Mark out the grid lines connecting the names together onto the paper. Use an HB or an F pencil, ensuring that it is very sharp; fuzzy lines will result in inaccuracy and inconsistency of writing. Do not press too heavily, some lines will need to be removed and you will be left with an indentation in the paper if you have used too much pressure or a pencil that is too hard.

When all the connecting lines are in place rule in the writing lines. Start writing your names from the top of the piece and work down, if the document is particularly large it might be easier to work from side to side in sections. First write all the larger sized lettering, then go back to the beginning and complete all the smaller lettering. If you make a mistake it can be removed fairly easily and usually without trace by using a typewriter rubber. If you are using one of the recommended papers you will be able to rub fairly hard without wearing through the surface. Make sure to remove all rubber dust from the cleaned area. If the surface looks a little rough, rub over with something smooth and flat such as a bone folder or burnisher. Do not use anything that will leave a mark on the paper.

When all the writing is complete, add the title. Rub out the writing lines, taking care not to remove any of the connecting lines which you still need. These are now painted in using red Designers' Gouache (or whichever colour you prefer). Squeeze a little from the tube and add enough water to give the consistency of cream. A little liquid gum arabic can also be added at this stage as red gouache is prone to smudging if touched (it is for this reason that the writing lines are erased before this step). Use a ruling pen and have the ends about $\frac{1}{32}$-$\frac{1}{16}$ inch (1-1.5mm) apart. Fill the pen with paint and use a ruler with a bevelled edge to prevent the ruler-edge from touching the page and the paint (see Fig. 82). Rule the horizontal lines very carefully, working from the top to the bottom of the page. Do not draw the vertical lines until the horizontal lines are absolutely dry.

If illustrations are included, draw them accurately on layout paper then trace them onto the tree and paint them in.

Trim the borders of your family tree and it is ready for framing.

Ruling pen

Ruler with bevelled edge

Newly drawn line

(Fig. 82) *Using a ruling pen*

Alternative layouts

Some people prefer to include only their direct ancestors, i.e. their parents, grandparents, great-grandparents, etc., rather than putting in every cousin and other relatives and their spouses. This makes a much simpler chart to draw up—if not so interesting. As each generation is double the size of the previous

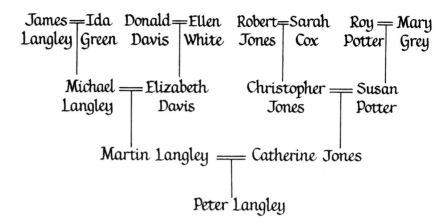

(Fig. 83) Composing a tree of direct ancestors only

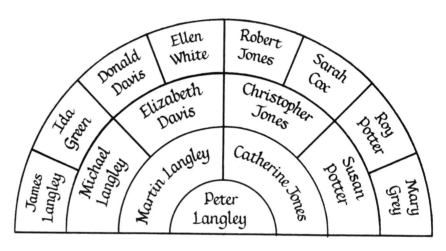

(Fig. 84) A family tree in the shape of a semi-circle

one you would have a pyramid shaped chart. Fig. 83 shows a four generation pedigree written in this way.

Sometimes the names are arranged into a semi-circle divided into segments (Fig. 84). For this method you would need a very large set of compasses. If you want to include a lot of biographical information with particular people this method is not recommended, as you do not have a great deal of spare space.

For decorative purposes you can make your chart actually look like a tree with the names written on the branches and leaves (Fig. 85). This method can look very attractive but the information is usually difficult to read. Again there is very little room to fit any biographical information unless the tree is made on a very large scale.

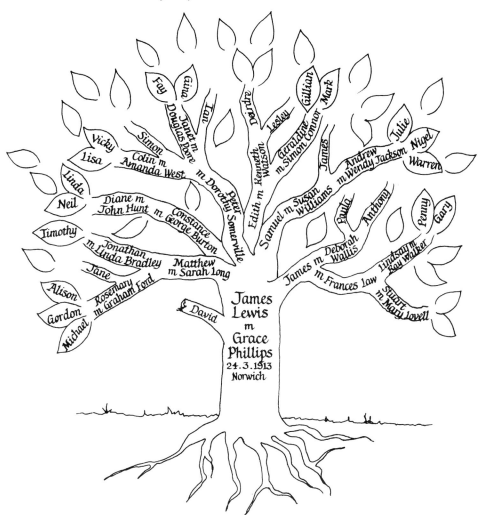

(Fig. 85) A family tree in the shape of a tree!

7 Creating a certificate

Hand-written certificates are always in demand for a variety of events. Birthdays, weddings, and other special occasions can be commemorated with a decorative scroll; they can be given as awards for competitions, or by organizations requiring something special for one of their members on their graduation to a higher post or perhaps their retirement. A certificate can be a simple sheet of lettering or an ornate illuminated piece on vellum, tied with ribbons and presented in a special case.

If you are asked to make a certificate you will probably be given a typed or hand-written sheet of the information to be included, along with details of any other things needed such as company logos, signatures, seals, coats of arms, etc. Very often the client will have a good idea of how he or she wants the layout, and which lettering styles are to be used. Occasionally you might get free rein to do as you please. Whether you are designing completely yourself or working to the client's requirements the steps to go through are basically the same.

Layout

Given a typewritten sheet of information, as in Fig. 86, you should proceed in the following way. Decide and mark those parts of the text which need emphasis. Usually the most important is the name of the recipient, Simon Wendle in this case, and the nature of the certificate—Diploma in Science and Technology—and possibly the name of the giver, University of Wessex, or the date. These lines can be written larger than the rest of the text, or in another colour.

If not pre-determined for you, decide roughly the size of the certificate in conjunction with the lettering sizes and layout you have in mind. (If you are planning to include ribbons on the scroll, extra paper is needed at either end, see page 125-126).

```
University of Wessex

DIPLOMA IN SCIENCE AND TECHNOLOGY

This is to certify that

SIMON WENDLE

has completed at Bartholomew's College
during 1984-1987 an approved course of
study in

Civil Engineering

that he has passed in the subject all
examinations required and that the Senate
has this day conferred on him this diploma.

24th July, 1987

Principal......................

Chairman, Wessex Science
and Technology Board...................

(Also to be included Wessex Univ. shield)
```

(Fig. 86) The information that needs to be included on the certificate

You can make quick sketch layouts with double pencils or a fibre-tipped pen and paper to give you an initial idea and something to work from. Fig. 87 shows the preliminary sketches made for the text supplied in Fig. 86. You can consult with your client at this stage to see which is the preferred layout. If the first sketch—a straightforward centering of each line of text—is chosen, your next step is to sort out the lettering sizes. The following section on centering is very useful, for many types of work, poems, cards, notices, etc. often need to be centred for a good layout.

Start with the size you think will do for the large areas of text. Write out one or two of these lines and see if they will fit well onto a page of suitable dimensions. Have a large sheet of paper with the likely dimensions of the certificate ruled on it. Add each size of lettering to the sheet as you write it. For the time being you can just cut the lines of words out and lay them on the layout paper. Try different sizes if necessary until you have got a

*(**Fig.** 87) Certificate roughs*

page of writing with lettering sizes that complement each other and look well balanced. Compressed Foundation Hand or Italic is recommended to begin with as it is a clearly legible hand and suitable for the nature of most certificates. Roman or Versal capitals could perhaps be used for the main name. Skeletal Versals (see p. 58) are fairly simple and would add a decorative touch.

When sorting out your lettering styles remember that you want styles that blend well together but also good contrasts. Do not combine too many different hands in one piece, in the mistaken impression that the results will be highly decorative. Stick to 2-4 so that you have an harmonious group rather than a jumbled, confusing selection.

Centering

Having decided all the lettering sizes it is a simple job to centre them. Move the strips of lettering carefully to the side of the layout sheet, trying if possible to keep them in the right order, then draw a vertical line down the centre of the sheet (see opposite). Take each strip of text and measure it, marking the centre. This central point is placed on the line on your layout sheet (see opposite). Stick the strips on with masking tape as explained on page 113. Whilst you are doing this you can also judge the distance apart that the lines of writing will be. Do not forget to leave plenty of room for the ascenders and descenders.

If signature lines are to be included they should be ruled on scrap paper to the desired length and positioned on the layout along with the text. Allow plenty of room for the signatories to put in their names as it is a great pity to have the certificate spoiled by squashed-up signatures. Any logos, drawings, or the

coat of arms in this case, should be sketched roughly to size on spare paper and positioned.

At this stage when the names, etc. are only fastened on by the masking tape, it is easy to change your mind and alter the positions of parts of the layout. Never make do with parts that you are not sure about. Try a different size or position and compare it with the first; it is well worth this extra effort to be really happy that you have chosen a good layout.

If either of the other initial roughs in Fig. 87 was chosen it is obviously not necessary to draw the centralizing line on the layout paper. You can go straight ahead as you write out the text lines and arrange them about the page until you have the layout you want.

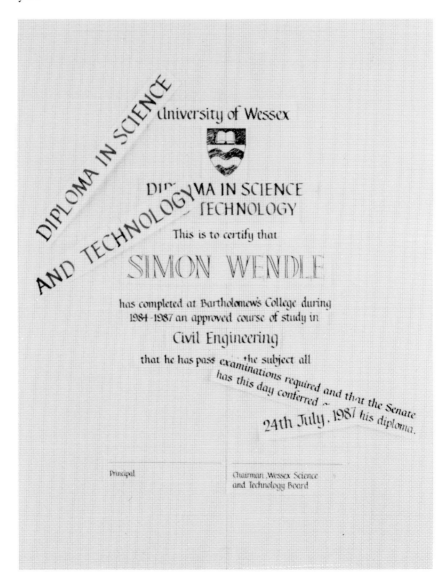

Centering strips of text on a layout sheet

When deciding which parts of the certificate to write in colour you should try and achieve an even spread of the colour, or colours, across the page. Consider the overall pattern of the areas of black text and those of colour. If you decide to move away from the traditional colours of red, blue, or green, make sure that the colour chosen is not too subdued in comparison with the black. In other words, have a page of matching tones (unless it is your particular intention to create a contrast for a special effect). It is wise not to combine more than two extra colours as the eyes will again be confused, detracting from the legibility of the text.

Work order

For the finished piece of work choose a fairly thick, robust paper as the certificate will probably be handled a great deal. 160gsm Canson 'Mi-Tientes' paper is a good choice. Cut it to size with the grain running in the direction you want. If the paper you choose has watermarks it is preferable to have these the right way up if possible. Take your layout and measure the positions of the writing lines and transfer them to the paper.

Try to touch the surface as little as possible to avoid any dirty marks getting on to it. Rule the lines in carefully and lightly with a sharp H or F pencil. For the lines on a centralized certificate you can measure how far each line extends to either side of the centre so that you will know where to start and finish writing.

Start the text by writing with the more plentiful nib size—in other words do the main body of the text first. If you are going to make mistakes this is where they will probably occur, and therefore, if they are irreparable, it is better to have had to scrap as little as possible of the previous text. It is possible, however, to remove most simple mistakes such as spelling errors. The pencil eraser is particularly useful here as you can be more precise with the thin pointed end of rubber than with a larger piece. With thick papers such as the one recommended for this work, you can afford to rub quite vigorously. Ink will come off fairly easily, but paint colours, especially red, are apt to leave a slight stain. Remember to carefully remove all the rubber dust so that it does not clog the pen when you write the correct word over the cleaned area. Use a burnisher (see page 145) to smooth down any surface area that has been roughened. Write the new word or letter in with great caution, the ink may be liable to spread if the fibres are too loose.

When the lettering written with the first nib is dry, the second is written in. Work methodically through the sizes, putting in the title last as this is the most noticeable part and needs to be well positioned. For the centralized lines write from the first

mark to the last, with luck the final word should fall nicely into the remaining space. This does not always happen though, as you do not always write exactly the same from one day to the next. Sometimes you will unconsciously compress or widen the letters, especially if you do the finished piece several days after doing the rough. Not only this, but sometimes just the fact that you are working on the finished piece can make you write differently. When doing the rough you know that mistakes are not terribly important, but you are under pressure with the finished article to do it right first time.

If you are coming to the end of a sentence and you can see that the writing is going to fall short or over-run slightly it is better to expand or compress the last few words or letters to make them fit. You will find that this will notice far less than a line of lettering that sticks out on one side or does not balance with the rest of the piece because it is too short. Alternatively you can fill in a gap where a line falls short with a line filler (see page 153). If you are a perfectionist, or time is not important and the scrapping of the materials does not matter then you can of course start again, but very often this luxury of time and expense cannot be afforded. If you have lines in other colours work these in gradually with the black lines as you go along through each nib size.

When choosing colours you can pick out those that are in the illustration or logo if there is one, so that the certificate has a more unified appearance. If there are no colours, you can choose what you like, though as previously explained, bright colours such as red, blue, and green are preferable as a contrast to the black. The information given in Fig. 86 shows that the main shield is principally coloured blue, so the main name and the signature lines can also be this colour. Put the signature lines in last, with the aid of a ruling pen if possible.

Draw the illustration accurately on a separate sheet of layout paper and transfer it to the certificate using red transfer paper or tracing-down paper which comes in packs of several different colours; this avoids the lengthy process of tracing over the back of the lines on the original drawing then tracing through the front again onto the work. Transfer or tracing-down paper is available from most art shops.

The colours should be painted in with flat colour as explained on page 151. If the illustration is black and white it can be done with either the pen itself, a small brush which is reserved especially for ink as ink spoils brushes very much more quickly than paint, a mapping pen, or a special ink-drawing tool such as a Rotring pen. It is a good idea to finish the whole piece off with a simple border—even a single line around the work adds a more polished look. The completed certificate is shown overleaf.

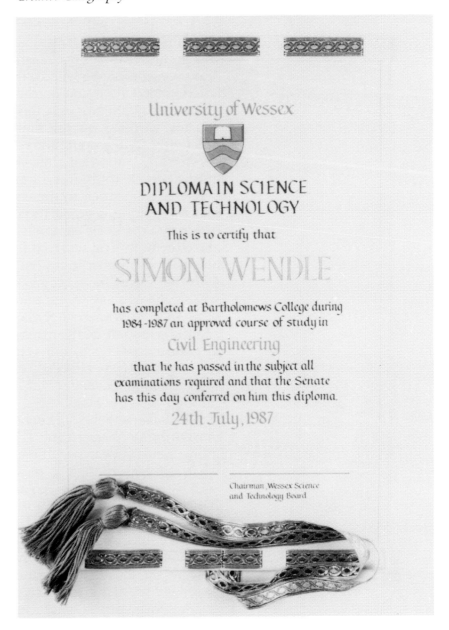

Certificate completed with ribbons (size 8¾×14 inches/22×35cm)

The writing lines can be rubbed out carefully with a soft rubber such as the 'Magic Rub'.

Ribboning

For important and prestigious certificates ribbons can be added. They are used for tying the scroll up for presentation or just as a decorative embellishment. It is fairly easy to add these to a certificate, and as you can buy ribbon in a wide range of colours

and designs to suit the colour scheme and contents it is an excellent way of finishing off your work. Ideal braids are sold by 'Vanpoulles Church Furnishers' (see List of suppliers, page 158). You can order them by post and Vanpoulles will send you sample pieces on request. Braids available in the average High Street haberdashers tend to be too plain and of insufficient weight.

For most scrolls you will need about 6 ft of braid and also two tassels in a matching colour for the ends. Small tassels can be purchased from most haberdashers. If the ones you get are over three inches long trim them down slightly. You can make your own with embroidery twine if necessary. You will also need a very sharp knife and a metal ruler, a bone folder (a thin, flat, smooth piece of bone for folding paper flat), glue that dries clear, a needle and cotton.

If you are going to have ribbons on the certificate you will need to have extra paper at either end from the start. Most suitable ribbons are about ½ inch (1.25cm) wide and you need approximately 3½ times the ribbon width at each end of the paper.

At the stage when you have determined the size of your certificate, that is, when the lettering sizes have all been worked out and your layout is complete with sufficient border all round, then you must add on the extra paper for the ribboning. Measure the width of your ribbon, add ⅙ inch (4mm) and make

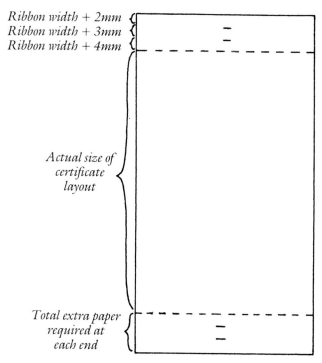

Ribbon width + 2mm
Ribbon width + 3mm
Ribbon width + 4mm

Actual size of certificate layout

Total extra paper required at each end

(Fig. 88) *Calculating how much extra paper you require for adding the ribbon*

a mark at either end of the certificate for this distance (Fig. 88). Measure the same distance plus ⅛ inch (3mm) and mark this distance from the second mark then measure that same distance again plus another 1/16 inch (2mm). This whole distance is the amount of extra paper required at each end. Cut out your sheet to include these measurements then go on with the certificate as before, not forgetting that all measurements and lines should come between the two extra areas.

When the calligraphy and artwork on the certificate is complete, begin the ribboning. Start with the top—or if the certificate is landscape, the left-hand edge as this is the edge that does not have the ties and so is easier. Rule lines right across the sheet at each of the three ribbon width marks. Fold the edge of the paper inwards so that the edge meets the second line and the first line is the crease (Fig. 89a). Press firmly but carefully with the bone folder so that the two thicknesses lie close together and you have a nice crisp fold. Fold the new edge to meet the third line (Fig. 89b) and press again. Rub out the last line to prevent it showing when complete. Repeat the folding procedure at the other end.

Go back to the top folds. When the ribboning is finished there will be three equal sections of ribbon showing along this strip with smaller equal spaces in between and at either end. To find the measurements for this divide the width of the whole strip into 13 equal parts using the method described on page 82 or by measuring with a ruler. Now measure alternately along the strip one part then three parts (Fig. 90) to the end of the strip. If you have measured correctly this should work out exactly.

At either side of each mark make two others approximately 1/16 inch (1.5mm) apart. Now draw vertical lines from just inside the edge at the top of the folds stopping at the same distance from the bottom edge of the folds (Fig. 91a). Go to the bottom set of folds and repeat the procedure, but also measure the exact centre of the strip and make marks either side but slightly wider apart, 1/12 inch (2mm) should do. Measure in 1/12 inch (2mm) from the top and bottom of each set of folds and rule across the ends of each pair of lines (Fig. 91b). You now have a set of thin oblongs which have to be cut out, through which the braid will

(Fig. 89) Making the folds for ribboning the certificate

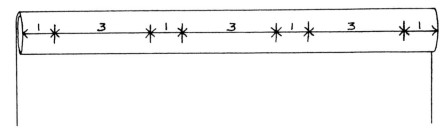

(Fig. 90) Marking the top edge of the certificate for placing the ribbon

(Fig. 91) Marking cutting lines

be threaded. Carefully cut with a sharp knife and metal ruler through all three thicknesses.

Vellum can sometimes be quite difficult to cut, and as you need to be fairly accurate use the diagrams in Fig. 92 to help you. Cut half way along each line, then turn the certificate round and cut from the other end to meet the first cut. This will give you sharp corners and avoid the risk of cutting too far. You need hardly more than press the knife into the tiny top and bottom lines to cut them. It may help to open up the folds and cut each layer separately once you have made partial cuts through the top layer which mark the correct place on the layers underneath.

Turn the certificate over and mark each of the four corners, from the outside edge inwards, with another of the measuring parts (Fig. 93). Make the little oblong to cut out in the same way as before, but this time open out the folds and cut it through *one* thickness only. When all the cuts have been made and the centre pieces removed, the opened-out folds at the bottom should look like the diagram in Fig. 94 (the top folds will not have the three wider central slits). Rub out all the pencil marks on both sides taking care not to damage the cuts.

(Fig. 92) Cutting procedure for braiding slots in vellum

Cut a strip of braid 1½ times the width of the certificate (1½ times the height if you are making a landscape certificate) and divide the remaining ribbon into two equal pieces. The braid is now threaded through the slits. As the braid can be easily damaged by being pulled back and forth through the slits, you should make as few threadings as possible. Follow the diagrams

(Fig. 93) Marking final cut, through one layer only

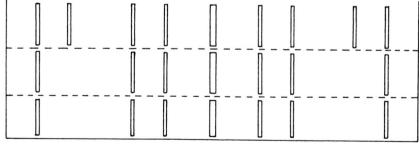

(Fig. 94) What your pattern of slits should look like at the bottom edge of your certificate when it is folded out flat

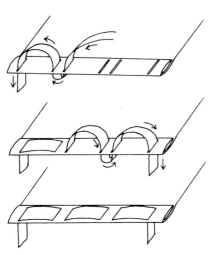

shown below for the top folds.

Pass one end of the shorter piece of braid (right side up) downwards through one of the centre slits pulling through half the ribbon. Thread it to the outside edge.

Now take the other end of the ribbon and thread it through the slots in the opposite direction.

Pull both ends gently so that the ribbon is taut.

The following diagrams show how to thread the bottom folds.

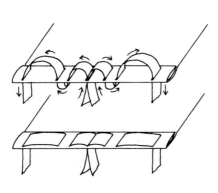

Take one of the long pieces of braid and thread it upwards through the wide centre slit then to the end as shown. Do the same with the other piece in the opposite direction, making sure you have both pieces the correct way up and that the second piece through the centre slit does not pull the first piece up with it. Pull both pieces taut, leaving about 3 inches (7.5cm) of braid hanging at either end.

Turn the certificate over and finish off all four corners as shown below:

The back of the certificate should look like this in each corner

The loose ends of ribbon are carefully tucked into the final slots in the back

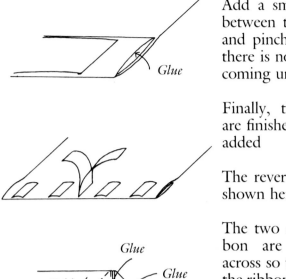

Add a small amount of glue between the folds at the end and pinch them tight so that there is no danger of the ends coming undone

Finally, the bottom ribbons are finished off and the tassels added

The reverse side should be as shown here

The two centre pieces of ribbon are folded diagonally across so that the right side of the ribbon faces to the front of the certificate. Apply a little glue under each of the areas where the ribbon is folded over as shown

Figs. 95a and 95b show back and front of the bottom ribbons when finished.

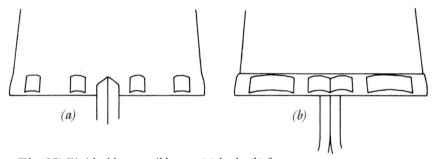

(Fig. 95) *Finished bottom ribbons—(a) back; (b) front*

Tassels usually have a loop on the end, and this is used to attach them to the ribbons. There are two ways of doing this:

For method (a) turn over a small amount of the end of the ribbon then turn the corners in diagonally. Place the tassel loop in between the folds so that it lies to one side, then sew up the end with a triangle of stitching, making sure that the tassel is held firmly.

(a) *Stitching*

For the alternative and easier method, turn over a small amount of braid then pass it through the loop in the tassel. Fold over about half an inch of ribbon and sew into place as shown. Sew with a needle and matching cotton, trying to make your stitching as invisible as possible.

(b) *Stitching*

Make sure, which ever method you have used, that the two lengths of ribbon are the same. You can cut them down if they are too long. The ends will probably need trimming anyway, having become frayed when passing through the slits.

Presentation

Although you can tie up the scroll with the ribbons and present it in this way, certificates are often presented in specially made tubes and boxes. These can sometimes be very elaborate but a simple presentation method is to make a decorative envelope. These are very useful if the certificate does not have ribbons. Choose a stout paper or card in a harmonizing colour. 'Canson' card is the right thickness and comes in a large range of colours from most art shops. Cut a piece as shown in Fig. 96.

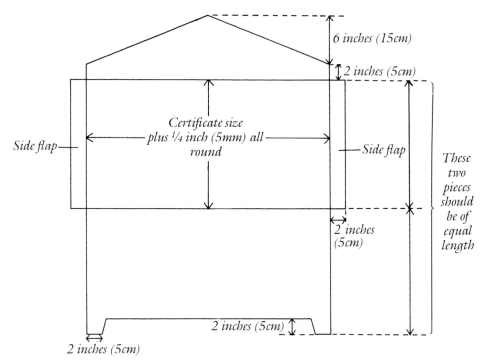

(Fig. 96) Cutting out an envelope

Using clear glue, stick the envelope together as shown in Fig. 97.

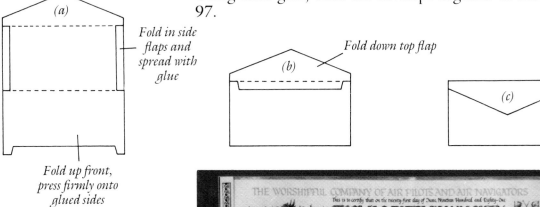

(Fig. 97) Gluing the envelope together

'Landscape' certificate on vellum with raised gold and aluminium leaf illustrations (size 24³/₄×10¹/₄ inches/62×25.6cm)

8 Illumination

As the word itself suggests, illumination is the 'brightening up' of manuscripts with the use of colour, illustrations, gold leaf, and other decoration. Some of the old medieval manuscript books are awe-inspiring in their beauty and detail. With care and attention it is possible to use your acquired calligraphic skills, plus some basic painting knowledge and the following instructions on how to gild, in order to create similar pieces of your own.

During the eighth to fifteenth centuries when these works were being executed, it was often by monks working together in scriptoria. The books were almost always religious in text; the scribes spending years transcribing the gospels, etc. There were also chronicles written of the daily life of those times, major events of the period, local happenings, etc. and it is from these books that modern historians are able to build up pictures of what medieval life was like. The scribes wrote with quill pens on animal skins using natural pigments and inks. Gold was frequently added.

These works were often commissioned by rich men and women, kings and queens. Great royal patrons of the book arts emerged, such as the Dukes of Burgundy, Otto the Great, and the Emperor Charlemagne (see Chapter 4). Ladies would carry exquisitely detailed prayer books with embroidered and jewelled covers. Books were not available to the lower classes; they were a luxury to be carefully preserved and stored by those who could afford them. It wasn't until the invention of printing in the sixteenth century that books became cheaper and more widely available.

Although some of the materials used by the medieval monks are unobtainable now, there are very similar substitutes available which will give good results. You can, as a starting point, copy one of your favourite pieces or design your own based on the illumination in such works as 'Les Tres Riches Heures du Duc

de Berry', the 'Book of Kells', or the 'Luttrell Psalter'.

Very often the pictures accompanying medieval texts can be crude and strange, in keeping with an age of superstition with no concrete evidence in the form of photographs or film to verify descriptions of strange animals and creatures. You may want to adapt some of the highly stylized pictures into more recognizable forms which are better pleasing to the modern eye. Too much adaptation, however, can remove the authentic look of a piece, so it is best to select a piece that does not require too much alteration. The amount of illustration you include in relation to text is a matter of choice. A fairly simple filigree border with delicately embellished Versals can be chosen, or a full scale historiated initial with rich borders in which the text is almost an optional extra.

Vellum, the traditional surface for books and documents, is still available in England. It is, needless to say, very expensive, but is the most beautiful surface on which to work, well worth paying for if the piece of work is important enough. Vellum is calf, sheep, or goat skin which has been carefully prepared with a smooth, velvety surface on which to write. The thinnest, whitest, and most flawless skins are used for writing and are known as manuscript vellum; they have been prepared on both sides for writing. The thicker and coarser skins are used for covering and binding books and are known as binding vellum. These vellums are cheaper than manuscript vellum.

Calfskin makes the best vellum; goatskin is generally coarser and has more markings and colouration. Although in medieval times the whitest skins were prized, there is a tendency these days for people to want more marked, coloured skins—presumably so that they are more noticeable and easily recognizable as vellum. For this reason, natural calfskin is now available with these qualities, having had the whitening processes omitted. The very white unmarked skins can look just like paper until carefully examined, so if you want your vellum to be obvious you will probably prefer the natural skins. The colour which is apparent in some medieval manuscript vellum is often not natural colour but the discolouration and dirt of extreme age.

Parchment is also still available. This is the inner side of split sheep skin: it is whiter and thinner than vellum and less expensive. Being much more delicate, mistakes cannot be so easily removed and the surface tends to be rather smooth and slippery and is inferior to vellum. The great advantage of vellum is that because of its strength and durability mistakes can often be removed without trace.

Although you can write on both sides of a skin of vellum there is a definite right and wrong side. One side is coarser and this is the flesh side; the other side is the hair side and it is smoother

and more suitable for writing. The flesh side needs extra care in preparation (pouncing) so always choose the smoother and better hair side if you are working on one side only of the vellum. If you make a book in which you have to use both sides of the vellum you must ensure when collating the pages that a flesh side page always faces another flesh side and each hair side faces another hair side page—also choose skins with similarity of colour.

There are some very good imitation vellums available now, vegetable parchment and 'elephant hide' being but two; they are much cheaper in price than genuine vellum. Vellum is not essential but it is the authentic material to use.

When you have chosen your intended piece of illumination and its size, you must prepare the surface on which you are going to work. If your illuminated piece is going to be on a single sheet it is an advantage to stretch the vellum over a board to prevent its tendency to buckle when warm. Medieval scribes obviously did not stretch their vellum as it was to be bound into books: however you will probably want to frame your piece when finished, so stretching is advisable, this will give you a smooth surface on which to work and prevent the vellum from buckling later when the piece is hung and exposed to changing atmospheric conditions. A piece of unstretched vellum when framed will almost certainly buckle in time, and this can have added problems if the piece contains gilded areas which can be damaged if they come into contact with the glass. If your work is not intended to be framed then stretching can be omitted, but it would be a pity after taking so much trouble to produce an elaborate work of art not to display it properly protected.

Vellum stretching

You will need the following:
 A piece of ply-wood of suitable thickness*
 Vellum (finished size required plus 2 inches (5cm)
 turnover all round)
 Blotting paper (same size as board)
 Sponge, bowl of water
 Bone folder
 Heavy-duty wallpaper paste with fungicide
 Handmade paper

* For a piece of work the size of an average illuminated manuscript, ¼ inch (6mm) thick plywood would be suitable. However, a larger sized piece of vellum would be strong enough to warp a thin piece of board, so bear in mind that the larger the piece the thicker the board needed. If your piece of work is over two square feet (60cm^2) the thickness of the board should be at least ⅜-½ inch (9-13mm).

Solid glue in stick form such as 'Pritt'
Several sheets of brown 'Kraft' paper.

From your piece of vellum choose the best area for working on, avoiding any blemishes. The size required is that of your finished piece plus a 2 inch (5cm) border on each side for the turnover. Cut the vellum and make a cross in pencil on the right side (the hair side), this will prevent the mistake of stretching the vellum the wrong way round.

A piece of handmade paper is needed for the back of the 'stretch'. This serves two purposes: one is just to neaten up the back, and the other is to pull against the vellum when it is retracting after being dampened and stretched over the board—a recommended handmade paper is T. S. Saunders paper. The size required is that of the board less $3/16$ inch (5mm) all round; this allows for expansion when the paper is soaked. If the paper has a grain direction it should run widthwise across the board (Fig. 98). The paper will contract more in the lengthwise direction which is the direction the board is most likely to warp, enabling it to counteract the pull of the vellum more. Handmade paper is used as it seldom has the one way grain of machine-made paper and therefore assists counteraction with the vellum in all directions.

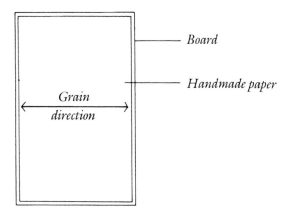

(Fig. 98) Cutting a piece of paper for the back of the 'stretch'

When you start to stretch the vellum it is best to work on a clean surface such as a large sheet of brown 'Kraft' paper. I usually work with several sheets underneath, removing each layer when it gets dirty. When you come to the gluing stage you must be careful not to get any glue on the top surface of the vellum; also keep the board as still as possible during the operation to avoid the top surface touching any glue on the 'Kraft' paper.

The board must be the size of the finished piece. Most do-it-yourself shops will cut a piece of board for you. If the edges are a little rough, smooth them down with sandpaper. Cut

a piece of blotting paper to exactly the size of the board. For the purpose of illuminated manuscripts white blotting paper should be used—as vellum is almost transparent the whiteness of the blotting paper will reflect the natural markings of the skin. When more proficient you might like to experiment with coloured blotting paper and discover the unusual effects that you can create in this way.

Stick the blotting paper onto one side of the board. The most convenient glue for this purpose is 'Pritt' or 'Uhu' glue in stick form. Only a little glue along the edges is needed to keep the paper in place (Fig. 99).

(Fig. 99) Sticking blotting paper to one side of the stretching board

Place the board on the vellum and mark the corners with a pencil about 1½ board thicknesses away from each corner. Mitre the corners (Fig. 100).

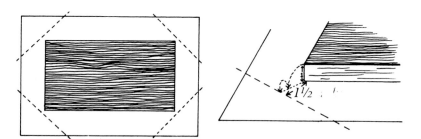

(Fig. 100) Mitring the corners of the vellum

Prepare some heavy duty wallpaper paste in a container—a plastic disposable cup is ideal as it can be thrown away after use. Use about a tablespoon of powder and mix with just enough water to make a smooth, easily spreadable paste. An old toothbrush is very useful for mixing the paste as this can also be used to apply the glue to the vellum. Put this mixture to one side.

With the vellum lying with the writing side facing downwards, using a clean, wet (but not dripping) sponge, dampen the vellum on the *wrong* side, taking special care not to get any water on the writing side as this can mark the surface. Gradually soak the vellum until it has expanded; never at any time allow excess water to float on the surface of the vellum as this will soak through, leaving marks on the writing side.

Damping the vellum to expand it before stretching

Place the board, blotting paper side down, onto the vellum, carefully positioning it on the marked corners. Apply the ready mixed wallpaper paste to the exposed sides of the vellum with

Stretching the vellum over the board

(Fig. 101) Pasting the board

(Fig. 102) Pressing the vellum onto the board

the toothbrush, covering the sides thoroughly; then apply paste to the board edges and about 2 inches (5cm) into each side (Fig. 101).

Starting with one of the longer sides, turn the edge of the vellum over the board—place your free hand firmly on the board to hold it steady and prevent it from moving about on the Kraft paper. Press the vellum flatly onto the board with the aid of a bone folder, ensuring that the vellum is pulled tight over the edge of the board and that there are no air bubbles under the vellum (Fig. 102). When the first edge is done move on to the other long edge: with the first side already fixed down, this side can be pulled more firmly. Do the same with the remaining two sides.

The corners require special care: apply a little extra glue to each one as you work, folding the vellum very carefully to obtain the neatest corner possible (Fig. 103).

(Fig. 103) Neatening the corner

Paste the whole of the uncovered side of the board, then soak the handmade paper and lay it on the pasted surface of the board; press down carefully with the bone folder (Fig. 104).

Stand the covered board on one edge to dry, rotate from time to time during drying to enable all the edges to dry evenly. The drying time needed is at least 4-5 hours; examine the stretch at intervals to see that it has not warped. A slight warp is not disastrous, but too great a warp can cause problems if the piece is to be framed—unfortunately if this should happen the only cure is to dismantle the whole thing and start again with a thicker piece of board: this obviously is to be avoided as the vellum is likely to suffer from too much handling.

(Fig. 104) Pasting the handmade paper to the back of the board

Pouncing

Whether you are using stretched or unstretched vellum it needs to be 'pounced'. The surface, as it is bought, is not at its best for receiving ink and paint so it is treated with various powders which will improve it. Pouncing is something which takes time to master but you will eventually learn to recognize when your vellum skin is ready for use. In the meantime you have to rely on trial and error. It is unlikely that you will completely ruin a skin

so do not be afraid to experiment. Ready-made pounce can be bought from vellum manufacturers or from Falkiner Fine Papers (see List of suppliers, page 157). If you feel courageous you can make your own.

Gum Sandarac is used as a pounce to hold the ink on the surface of the vellum and prevent it from spreading. Powdered pumice and powdered cuttlefish are slightly abrasive and remove grease from the vellum, whiting and french chalk can also be used for removing grease. A good pounce is a mixture of powdered pumice, powdered cuttlefish, and gum Sandarac which can be applied in one go. Many scribes prefer to use the powders separately, applying pumice first then the Sandarac. Falkiner Fine Papers sell pumice already powdered, and most pet shops sell cuttlefish which you will have to grind to a fine powder; gum sandarac is usually bought in crystals which also need to be ground down and is available from Cornelissen (see List of suppliers, page 157).

For the combined pounce use a heaped tablespoon each of pumice and cuttlefish to one teaspoon of gum Sandarac. This quantity stored in a small jar will last for many applications.

For the hair side, which is the side being used for the illuminated manuscript, sprinkle a little of the pounce over the vellum, then with a piece of scrap vellum about 5 inches (12.5cm) square rub the pounce into the vellum with circular movements, gradually covering the whole surface. If you detect any large pieces of cuttlefish or gum Sandarac, remove them as they could scratch the surface of the vellum. Continue the circular rubbing for 3-8 minutes, depending on the thickness of the skin. It is possible to overpounce so be careful not to roughen the surface too much: aim at a slightly velvety texture to the surface rather than a smooth slippery one, but you do not want a coarse surface.

Pouncing the vellum

Shake off the excess powder and give the surface a light dusting with a clean piece of cloth as too much powder left on the surface will clog the nib. If you are making a manuscript book and need to write on the flesh side also then you must be very much more cautious when pouncing. It is easy to pull up the hairs on the flesh side and this would make writing very difficult. Proceed slowly, examining the surface continually to make sure that it does not look too rough. When pounced, the vellum is ready for working upon so place it to one side in preparation for your design.

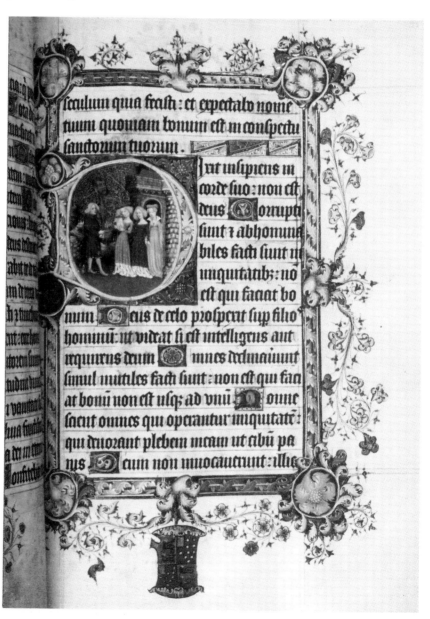

A page from the Bedford Psalter & Hours by permission of The British Museum (size, excluding margins, 9½×13 inches/24×38cm)

The design

I have taken as a model a page from the Bedford Psalter & Hours, a fifteenth century English book of hours (left). As most old manuscripts are written in Latin you can use a different text in English in order to make the piece legible to the average person. Gothic Blackletter is the hand used in this manuscript; most pages of Blackletter tend to be square blocks of text with any illustration set into the top left hand corner or left margin. You can to some extent stretch or condense words in Blackletter to fit the spaces you have available—this was done frequently by medieval monks who would also often simply break off a word in the middle when reaching the end of a line and continue the word on the next line just for the sake of neat edges. When a replacement text in English of suitable length and subject matter has been chosen it needs to be fitted into the available space.

First draw or trace as much of the original decoration as you want to use onto a sheet of thin tracing or layout paper and indicate with rough lines the area of the text: this will give you a guide to the amount of space you have for your lettering. Now fit the new text into the space available. If you decide to copy the original text of your chosen manuscript then it is worthwhile writing it in to make sure that you have the correct nib size and that you can make the lettering fit exactly.

Once you have the text correctly fitted into the available space you can complete the rest of the illustration, making any alterations you wish to the original design chosen and adding any other embellishments. In the manuscript illustrated I decided to alter some of the detail in the large initial. On the original was a rather gruesome picture of David proudly displaying the severed head of Goliath for the inspection of the three ladies present. I have omitted the rather undesirable object and simply left a gentleman paying his respects to the ladies. Apart from this alteration I decided to omit a shield which was suspended from the floral decoration at the bottom of the manuscript as this was not particularly attractive or relevant. Finally the floral work in the bottom left corner had to be balanced with that in the right corner.

The illustration was designed for the recto page of a manuscript book so this alteration was needed when transferring for display on a single flat sheet. Apart from these changes the illustration was copied exactly from the original. The colours in this particular manuscript are very vibrant red and blue, with various paler and deeper shades, and a few other colours in the initial letter. There is a very liberal covering of raised gold and black outlines around all the floral work.

When you have completed the design you can return to the vellum. The writing is always completed first, so measure from

the rough the area where the lines are to go and carefully rule the writing lines onto the vellum using a very sharp 2H pencil. Try not to touch the vellum with your fingers as grease can be transferred to the surface—always use a guard sheet beneath your hand (soft, absorbent paper such as kitchen roll is ideal for this) and eventually it will become second nature to move this guard with your hand as you work. Using the ruled lines, carefully write out the text in Chinese ink.

Do not worry if you make any mistakes, they can be removed from vellum fairly easily using a pencil rubber or a craft knife. The knife is used to carefully scrape off the error, but do make sure that the ink is dry before removing any mistakes. Another possible problem you might come across is a flaw in the vellum—you can sometimes hit a greasy patch which will not take ink, or a particularly absorbent area on which the ink spreads and creates fuzzy edged letters. As soon as you come to an area which has one of these problems, do not write any more before you treat the surface. Apply whichever of the pounce powders is necessary, i.e. gum sandarac to prevent spreading, pumice to remove grease, etc. You can confine the pouncing to a fairly small area, rubbing the powder in with your finger covered with clean cloth. Once the area has been treated try writing again, hopefully you will have cured the problem.

When the text is complete, the illustration can be traced from the rough onto the vellum using transfer or tracing-down paper, page 158. Outline the illustration with a very fine pen and ink. If you ever get the chance to look closely at medieval manuscripts it is very interesting examining those that were only partially completed as each stage in the preparation can be clearly seen. When the illustration has been outlined the next step is to do any gilding that is required; this must be done before the painting as gold will stick to paint.

Gilding

Raised gilding

Raised gilding is quite a tricky process and it would be wise to try a test run on an odd piece of vellum until you have mastered the technique.

Gold leaf is applied to the surface on top of a sticky plaster base called gesso. The gesso is painted or written onto the vellum in liquid form then left to dry. It is then moistened again slightly with the gilder's breath and the gold laid on to it whilst it is tacky. The preparation of gesso is most important, for if it is not made or applied correctly gilding will be a great deal more difficult, if not impossible.

Making gesso

You will need the following equipment:

Pestle and mortar
Glass or ceramic slab
Aluminium foil
Air-tight box for storage
Palette knife

The ingredients are:

8 parts slaked white plaster of Paris
3 parts white lead
1 part preserving sugar
1 part Seccotine glue
Pinch of Armenian Bole
Distilled water

The best measure to use is a very small spoon such as a mustard spoon or half teaspoon kitchen measure. This will make sufficient for a number of pieces of work. Gesso does not keep indefinitely (no more than 18 months) so there is no point in making larger quantities unless you intend doing many pieces. (You can buy ready-made gesso from the Duchy Gilding Company—see List of suppliers, page 158.)

Armenian bole, white lead, Seccotine glue, and slaked plaster are all available from Falkiner Fine Papers and L. Cornelissen & Son. A half pint sized pestle and mortar is suitable and can be purchased from kitchenware shops and some art shops. All your equipment must be kept scrupulously clean. Slaked plaster is purchased in lump form, so powder it by grating a little from the sides of the lump with a craft knife, and then measure 8 level spoonfuls into the pestle. Crush the preserving sugar to a powder with the aid of the pestle on the glass slab; add 3 level spoonfuls to the slaked plaster together with one level spoonful of white lead. Add the level spoonful of Seccotine glue, a tiny pinch of Armenian bole (to colour the gesso slightly), and a few teaspoons of distilled water, and grind the ingredients together in the pestle and mortar for 1 hour until the consistency resembles treacle.

When all the ingredients are thoroughly combined, pour the mixture in an even circle onto a piece of aluminium foil; use a palette knife to remove all the mixture from the sides of the pestle and mortar. Leave to dry for several hours. When the gesso is solidified and reasonably dry, cut into 8-12 equal segments as in Fig. 105. It is very important to cut right across the circle each time rather than cutting into squares, as when the gesso dries the ingredients tend to separate, some to the edges

and some to the centre. You must have an even amount of each ingredient in each portion used and the only way to achieve this is by cutting the segments right across the circle. Leave overnight to dry out thoroughly before using the first piece. Peel the gesso from the foil, handling each segment as little as possible, and store in an airtight tin ready for use.

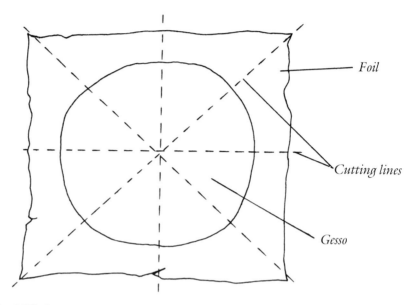

(Fig. 105) Cutting gesso into equal segments

To prepare a segment of gesso for applying to the work, place a piece in a small container and break into small pieces with a craft knife. Use a ceramic palette if you have one, or any small container which is not too deep. Add a few drops of distilled water to the pieces and leave to soak for about 20 minutes. The gesso will soften. Mix very carefully with the end of a thin paintbrush trying not to let any air bubbles form in the mixture, which should be the consistency of cream.

Identify all the areas that are to be gilded by colouring them yellow on your original rough design. Carefully paint gesso onto the areas to be gilded, using enough gesso to give a slightly raised appearance on the page. When all the required areas are covered in gesso leave to dry overnight. Gesso needs quite a long drying time to enable the plaster to dry thoroughly. The core needs to be hard before you begin laying the leaf on. If you tried to gild the gesso too soon, the top surface would appear to be dry and hard, but the 'core' would still be soft and as soon as you applied pressure with a burnisher the top layer would crack. It *is* possible to lay gesso early in the morning and gild in the afternoon, but this is taking a risk which is better avoided by the inexperienced gilder so overnight drying is recommended.

The next day when the gesso is dry, scrape the surface gently with a craft knife or scalpel to even out any irregularities and obtain a smooth surface—this will also help the gold to stick. Try to tackle this part of the gilding in the early morning when the air is slightly damper and cooler; hot summer afternoon atmospheres will leave you despairing of the gold ever sticking to the gesso because you will not be able to make it moist enough.

Gold leaf

For best results two different thicknesses of gold leaf are required—double and single leaf. G. M. Whiley sell both thicknesses in books of 24 sheets, each sheet being roughly 3½ inches (8.75cm) square. One book of each thickness will be plenty for your manuscript. You will also need the following:

> A pair of clean sharp scissors
> A large soft brush
> Glass slab or other smooth hard surface
> Burnishers

There are various types of burnisher and they are usually made from agate, haematite, or psilomelanite, agate being the cheapest and most widely available. Burnishers are used for polishing the gold to a brilliant shine—they come in various shapes and sizes and you will probably find the 'dog-tooth' (Fig. 106) the most useful. A pencil burnisher with a fine point is helpful for burnishing into the edges and around small areas, and a large flat burnisher can be used for applying heavier pressure to give a final polish to the gold. Various shops selling burnishers are given in the List of suppliers on page 157.

(a) Dog-tooth *(b) Pencil* *(c) Flat*

(Fig. 106) *Burnishers*

Your scissors must be clean and completely free of grease or you will find when you cut the gold leaf that it will stick to them and tear. The brush is needed to brush away the waste gold around the sides of the gesso shape. Burnishing must be done on a hard

flat surface—this prevents the possibility of the gesso bending and cracking when pressure is applied to it.

Before you begin to gild take a few sheets of paper and arrange them around the first piece of gesso to be gilded so that all the area around it is masked off. This will prevent the surrounding gesso from being touched or moistened before it is worked on. If you get grease on ungilded gesso the gold will not stick to it and it will have to be removed and new gesso laid. As you gild each area of gesso you can move the sheets to the next area, so covering up the finished piece and protecting it from being remoistened or damaged.

The gilding method is illustrated in Fig. 107, (a)-(g). Holding the book of single gold leaf open with one page hanging free use the scissors to cut a piece large enough to cover the first area to be gilded(a). Cut through both the gold and the backing paper and hold the cut piece on the very corner with your thumb and index finger so that the gold does not stick to

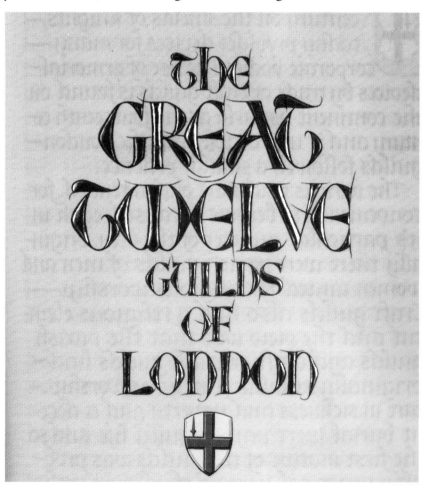

Gilded Lombardic letters from the title page of a manuscript book (page size 9½×12¼ inches 24.1×31.2cm)

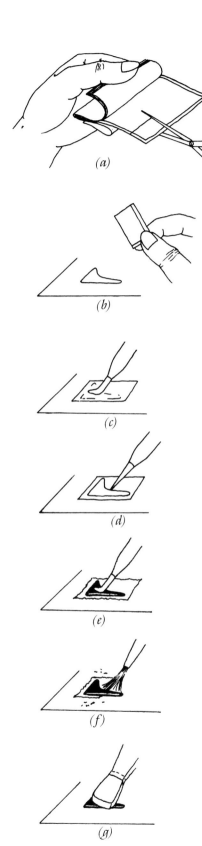

(a)

(b)

(c)

(d)

(e)

(f)

(g)

Fig. 107 *The gilding method*

your fingers(b). You will find it difficult to gild areas larger than 1 inch (2.5cm) square successfully in one operation, so work with fairly small pieces of gold leaf. Hold the gold above the gesso ready to be laid in place and breathe on the gesso with ten short, quick breaths to make the gesso surface damp and sticky, then quickly press the leaf onto the gesso, with the paper backing still in place on the outside, and rub gently with the dog tooth burnisher, covering the whole surface as quickly and smoothly as possible(c). Do not press too firmly or you will distort or crack the gesso, a fairly light pressure only is needed. Rub the pencil burnisher carefully around the edges, still through the paper backing, so that the gold leaf has been pressed over all the gesso that it touches(d). Remove the paper backing and burnish the gold directly but gently with the dog tooth(e). Use the soft brush to remove the excess gold from the surrounding area(f). You will now be able to see if the gold has stuck, as it will flake off when the brush touches it if it has not. Provided the first layer has stuck successfully you can repeat the process with a second layer of single leaf. You will find that the second layer will need fewer breaths to make it stick. Finally add a layer of double leaf in the same manner. This layer when burnished will give you a very bright sheen, especially if you use the large flat burnisher to finish(g).

Gilding problems

The 'breathing' action on the gesso is a critical step in gilding. Gesso is very susceptible to atmospheric conditions; in a humid atmosphere it may not be necessary to breathe ten times, but if the air condition is very dry you may have to breathe upon the gesso as many as twenty times to attain the necessary amount of dampness on its surface. If more than twenty breaths are needed then it would be advisable to abandon your gilding until the atmosphere changes, but you should not leave the ungilded gesso for more than three days as after this length of time it will be too dry to take the gold at all. If you are desperate to get it done then you can try using a steamy bathroom, having left the hot tap running and the door closed.

You might find that you have completely the opposite problem, that of the gesso becoming too sticky. If this happens, although the gold will stick easily, when you try to burnish, the sticky gesso will come through the gold and adhere to the burnisher. In this case you must decrease the amount of breaths you give the gesso so that it is just sticky enough to take the gold. Make sure you thoroughly clean the burnisher before proceeding again, as any roughness on it will simply scratch the gold off the gesso.

As mentioned, the second and subsequent layers of leaf will probably require less breaths once the first is successfully laid as

the gesso will with each application become slightly warmer and more congenial. Gold leaf also, to some extent, will stick to itself, so once the first layer is on satisfactorily each one following becomes easier. Between each layer use the soft brush to remove the excess gold from the edges of the gilded areas.

Do not over burnish, or apply too much pressure between each layer, or the gesso will crack or 'craze'. If this should happen there is again no alternative but to remove the gesso and re-apply it. If you need to re-apply gesso to an area, and the gesso which you originally mixed has dried up, then do not re-soak it and mix again—discard it and soak a fresh piece as you might find that enough of the adhesive content has evaporated off with the moisture to prevent the gold from sticking.

When your gilding is progressing well without any problems then gradually work over the whole page until all the gilding is completed. Remove all excess gold with the brush and then you are ready to move on to the next step—painting.

Do not be discouraged by what seems like a long list of pitfalls in gilding: it is a time consuming and sometimes tiresome process; you must have great patience and be prepared for disappointments—even the most experienced gilders have their days of sheer exasperation when the gold just will not stick. But do persevere; even the smallest amount of raised gold illumination really does look quite stunning and the amount of satisfaction from such an achievement is enormous.

Flat gilding

An easier method of applying gold to a piece of work is by using 'transfer leaf'. Transfer leaf is sold in books of 24 leaves similar to loose gold leaf but attached to the backing pages. It is laid onto the vellum using gold size. This is a yellow or clear liquid which is painted onto the areas to be gilded and allowed to dry. It is then breathed upon in the same way as gesso to make it sticky again and the sheet of transfer leaf is pressed on and burnished down; the backing sheet is then peeled away and the gold is burnished directly. A fairly light touch is needed whilst the size is still damp or the gold will be scratched off. This is a very much easier method of gilding and successive layers can be applied until the area is fully covered. You can always retouch stubborn areas with more size if the gold will not stick. Gold size can be purchased from Cornelissen (see List of suppliers on page 157).

There remains one other type of gold with which you can illuminate—gold powder, sometimes known as shell gold as it used to be purchased in shells. It is the easiest method of applying gold to a piece of work but it does not produce quite as brilliant a shine as that of gold leaf. The powder is bought by the penny weight (this is an old penny); it is mixed to a liquid with gum arabic and water then painted onto the work. Empty the

powder into a small container and in another container keep some distilled water. This water should always be used when mixing the gold powder or cleaning the brush as you do not want any impurities to get into the gold and dull it. Add about half a teaspoon of distilled water to the dwt (penny-weight) of gold powder, and then about six drops of gum arabic which you can measure by dipping your paint brush into the gum arabic bottle and letting each drop fall off the tip.

Keep a brush solely for painting with gold powder—mark it in some way so that you will remember it is your 'gold' brush. Whenever you use the gold powder you must mix it well as the gold particles always sink to the bottom, separating from the gum and water. Containers for storing gold should have lids. If the liquid should dry out remember to add more gum arabic as well as water when you remix. Your judgement must be used when adding the gum as too little will allow the leaf to flake off the page when you burnish, and too much will cause the burnisher to stick to the gold, creating blackish lines across it and dulling the shine.

To check that you have a suitable combination: when you have mixed the powder, paint a small square about ½ inch square ($1cm^2$), let it dry then burnish it—do this lightly at first, applying more pressure as the shine starts to appear. If the gold starts to flake off add more gum and do another test piece. If the gold is not burnishing well and you can detect any sort of stickiness from the gold or resistance to the burnisher then the gum content needs to be reduced. Leave the mixture to dry out, the liquid will soon evaporate away, then add a little more water and start again. It is obviously easier to add gum rather than take it away so use caution when you add it, testing after each drop until the gold is burnishing well.

When you paint the gold powder onto the work let it dry completely before burnishing but do not wait too long after it has dried as the shine will be better when burnished fairly quickly after drying.

You can buy gold powder in small tablets as well as loose powder. The powder has already been bound with gum and water and you can use it in much the same way as cakes of paint. I have found that for some reason this gold does not produce as bright a shine as the loose powder.

On some pieces you can use a combination of raised and flat gilding to good effect. Do the raised areas first then paint in the powdered gold afterwards. Sometimes an attractive two-tone effect can be gained by burnishing only parts of the powder gold, leaving matt areas to contrast with the shiny parts.

Aluminium leaf

For representing areas that are silver, or similar metal colours,

you can use aluminium leaf. Silver leaf is available but it tarnishes so quickly that it is not suitable for illumination. Substitutes such as platinum and aluminium are therefore used. Platinum is as expensive as gold and so aluminium is the obvious choice to begin with—it is inexpensive and produces good results. It does not stick to itself in the way that gold does so only one layer can be applied. Aluminium leaf is thicker than gold leaf and does not stick to the gesso so easily either so a special recipe is needed with more glue and sugar:

8 parts slaked plaster
3 parts white lead
1½ parts preserving sugar
1½ parts Seccotine glue
Pinch armenian bole
Distilled water

Lay the gesso and apply the leaf in the same way as gold leaf but make sure you burnish it immediately as it does not burnish at all if left for a time—you will simply rub the leaf off. You must be very careful when laying aluminium leaf as if it does not stick all over the first time you will have to remove the gesso and start again.

Adding colour

When the gilding on a piece of work is completed the colours can be added. If you are anxious to get as close as possible to the colours used in medieval manuscripts then you should use pure powder pigments—these can be purchased from Artists' Colourmen such as Rowneys, Winsor & Newton, etc. They are obtainable by post from Cornelissen (see List of suppliers on page 157) or you may find some at your local art shop. The quality of powder paint does vary a great deal so make sure you get the finest quality powder as poor quality colours will spoil your work. Good quality powder pigments are usually fairly expensive and are rather fiddly to use, but their advantage is their clarity and the vibrant colours which are by far the closest to those used originally in old manuscripts—indeed some of the pigments available are identical to those used by medieval scribes. One other advantage is that they will not rot the vellum as some modern mediums can do.

The easiest medium with which to mix the powdered pigment is egg yolk. It must be carefully prepared in the following way:

Make a smallish hole in both ends of the egg shell, larger than a pin prick but no more than about 3mm across, and

let the egg white run from the shell into a small bowl: this will leave the egg yolk still inside the shell within its sac. Break the yolk sac by pricking carefully and let the yolk run into another small bowl, leaving the sac behind in the shell. This bowl of egg yolk is the binding agent for the colour; it should be mixed with an equal amount of distilled water. You may be able to find an easier way of separating the yolk from its sac but it is important that only the yolk is used without any impurities.

Mix a small quantity of the pigment with some of the binding agent to a consistency which is reasonably fluid but will not be too transparent when painted with—aim at a consistency similar to single cream, though certain pigments may require a slightly thicker or thinner consistency. When mixed with the pigment and painted on to the vellum or paper surface the yellow colour of the egg yolk will disappear, and when dry you can paint successive coats over the top without the underneath layer moving.

Instead of powder colours you could use the more widely available 'Designers' Gouache' mentioned in previous chapters. This is a very much easier medium with which to work but the glycerine which the gouache contains will eventually rot the vellum. You may feel that the many years which will pass before this happens make it an unimportant problem, but if you want your work to last as medieval manuscripts have done then you should use powder colours.

Whether you are using powder pigments or gouache, the coloured areas on the work are built up in the same stages, from the lightest to the darkest. Work through each area of colour in the following way:

Prepare a colour, i.e. red, at its normal strength and also prepare some white. Add a tiny amount of the colour to the white; this is the base colour which you paint over the whole area where red is needed.

With the base coat completed add a little more of the full strength colour to it, making a slightly darker shade. Paint this over the base coat where darker areas are needed.

Repeat the process with a slightly darker shade so that you are building up the impression of a three dimensional form.
Now use the colour at its full strength for the final shading. Go through this process with each different colour.

Highlights and detail can now be added, such as the delicate white pattern shown—this obviously shows up best over the darker areas of the shape.

The shapes can be finished off by adding shadows to increase the three dimensional look.

Powder pigments mixed with egg yolk do not keep very long so it is best to aim at painting all areas of a particular colour on the same day so that the excess paint can be discarded and fresh colours mixed the following day.

There are various other types of illumination used which have special names. 'Diapering' is the name given to delicate patterns painted over large areas of plain colour to give them more interest. They can be, and most often were, geometrical or floral in design. Fig. 108 shows some examples taken from designs found on old manuscripts.

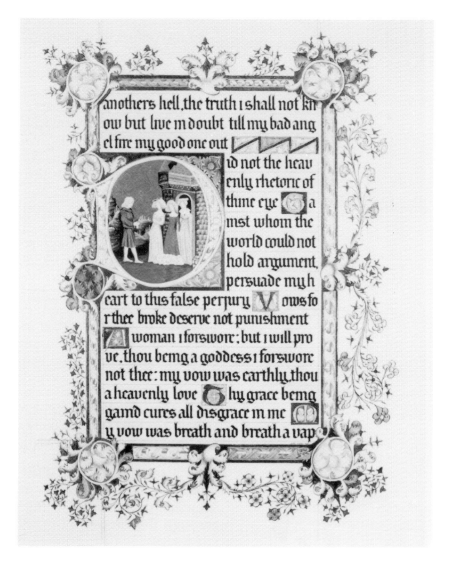

(Fig. 108) Some patterns called 'diapering' found on ancient manuscripts

Recreation of an illuminated manuscript based on the original illustrated on page 140 (size, excluding margins, 9½×13 inches/24×33.5cm)

If large areas are diapered it can be a laborious process but the results are usually very pleasing. Another form of diaper used on raised gilding is where patterns are actually embossed into the gold with the aid of tools such as the pencil burnisher.

'Filigree' illumination is used around individual letters in borders and in parts of whole pages of illumination. Fig. 109 shows an example taken from a manuscript of the thirteenth century.

Line fillers were a common means of decorating a page and keeping a pleasing texture throughout by filling up gaps. Sometimes the pen can be used for these at the time the writing is being done, or they can be put in more elaborately afterwards with a brush (see Fig. 110).

Mounting and framing

When the work is complete it can be framed. Mounting is essential on pieces with gold illumination—the gold must not be allowed to come into contact with the glass as friction will cause it to crack or rub off. A mount of standard thickness ($\frac{1}{12}$-$\frac{1}{6}$ inch 2-4mm) will provide enough space between gold and glass, at the same time providing a good surround for the work. Pictures generally look better with a mount, and mountboard is available in a wide range of colours. Framers usually have a good selection and are happy to help you with your choice.

Alternatively you can cut your own mount. You will need a knife with a sharp blade such as a Stanley knife and a cutting board. A piece of block board about 2×3 feet (60×90cm) will do.

For a piece of work about the size of the medieval manuscript shown, a mount of about 2 inches (5cm) wide would be about right. The bottom border generally looks better a little wider so make this about 3 inches (7.5cm). Measure the size of the piece of work and calculate the dimensions needed for the mount. Cut out the required size from the sheet of mount board. Mark the border and then carefully cut the window using a metal ruler. The ruler should be covering that part of the board which will be the mount then if your knife slips you will not spoil the mount. It will probably take two or three strokes to cut through the board so make sure that each cut is directly on top of the previous one (Fig. 111).

Cut along the four straight edges as accurately as you can, then cut through the corners, which will still be attached, with special care so that they are neat and precise.

You can buy a mount cutting gadget from art shops for cutting edges with a bevel. This looks very much nicer than a vertically cut edge and the cutter is fairly simple to use. A good

(Fig. 109) 'Filigree' illumination

(Fig. 110) Line fillers

Cut straight edges not quite
to corners

Metal
ruler
Mount
board

(a)

Cut carefully outwards
from each corner

(b)

(Fig.111) *Mount cutting*

Miniature illuminated poem with filigree work (actual size 6¹/₄×4¹/₂ inches 15.9×11.4cm).

example is the 'Daler' mount cutter—it is a little more expensive than some other makes but is recommended if you want good results.

When the mount is cut, rub out any pencil marks that may be showing on the board. You can now take the work along to the framers for the last step in creating your finished picture.

9 In conclusion

The traditional illuminated manuscript which you have learnt
how to make in the previous chapter is a very useful exercise for
learning all the illuminating procedures such as preparing
vellum, gilding, and applying colour. It is therefore a very
worthwhile, not to mention attractive, piece of work to do but
copying medieval manuscripts does not allow for much use of
your own personal taste and character. Calligraphy is a
wonderful medium with which to express individuality, and
therefore, having tried some of the projects in this book, now is
the time to think about developing your own ideas.

If you have learnt thoroughly the basic letterforms and
techniques shown in Chapters 2 and 3 you should be writing
with a reasonable degree of skill and confidence. You can now
work on developing your own style of lettering. This does not
necessarily mean creating a new calligraphic 'hand' but adding a
certain character and uniqueness to those you already use.

In a way you *will* be creating new hands of your own, because
even something as plain as Foundation Hand when written with
your own style will be that little bit different from anybody else's
Foundation Hand. The differences need not be obvious ones,
such as novel serifs or spacing, but little refinements and
subtleties such as more positive, deft strokes giving elegance and
finesse. It takes some time, for many people years, to really have
the knowledge and confidence to make your own letters
distinctive: before this happens you will probably have been
trying your hardest to make your letters exactly like those in the
copy books you have been using. Do not feel that you have to
search for a hidden individuality; it is more likely to evolve
naturally of its own accord. If, however, you do not wish to be
tied down to copy book styles for too long you can make a
conscious effort to bring a more personal style into your work.

One of the quickest ways to acquire individuality is to write
without guidelines. Do away with the top line at first—it is not

as difficult as you might think to keep the writing relatively even and you will automatically feel freer with the pen. The obvious follow on to this is to try writing on curved or wavy lines, they can be very expressive and make your work very decorative. Circular and other shaped pieces are fun to do too: you can for instance make your lettering represent the subject it is describing. Do away with the bottom line and try writing freely for a while, even if you go back to writing between lines for more formal pieces you will probably have benefitted from the experiment.

The 'rules' laid down in Chapter 2, although important to begin with, do not need to be rigidly adhered to indefinitely. In their day each of the historical alphabets in Chapter 3 was adapted by different scribes to their individual tastes and requirements. Just studying the history of writing and the different hands that have evolved over the years is a valuable guide to how the individual can offer unique solutions to the problem of creating exciting and different pieces of work. After experimenting with historic hands and learning from them the calligrapher can move on to create new contemporary styles that belong to the twentieth century.

List of suppliers

Falkiner Fine Papers Ltd
76 Southampton Row,
London WC1B 4AR

papers, vellum, gilding
materials, bookbinding
materials, nibs, pens, ink

L. Cornelissen & Son Ltd,
105 Great Russell Street,
London WC1

powder pigments, gilding
materials, quill pens, gold leaf
in small quantities, slaked
plaster, pouncing materials

William Cowley,
Parchment Works, 97
Caldecot Street, Newport
Pagnell, Bucks MK16 0DB

parchment, vellum

Winsor & Newton,
Whitefriars Ave, Wealdstone,
Harrow, Middx HA3 5RH

'Designer's Gouache', brushes

George M. Whiley Ltd,
Firth Road, Houston
Industrial Estate, Livingston,
West Lothian, Scotland EH54
5DJ

gold and silver leaf, transfer
leaf, gold powder, burnishers

Duchy Gilding Company,
The Old Mortuary Studio,
Gyllyng Street, Falmouth,
Cornwall

all gilding materials including
ready-made gesso

Rexel Art & Leisure Products,
Gatehouse Road, Aylesbury,
Bucks HP19 3DT

William Mitchell pens

T. N. Lawrence & Son Ltd,
119 Clerkenwell Road,
London EC1R 5BY

papers

Rotring U.K., Building One, GEC Estate, Wembley, Middx HA8 7DY	'Artpens' and 'ArtistColor' (new range of calligraphy fountain pens and inks) as well as technical drawing instruments
E. S. Perry Ltd, Osmiroid Works, Gosport, Hampshire PO13 0AL	Osmiroid pens and nibs
Vanpoulles Church Furnishers, 1 Old Lodge Lane, Purley, Surrey CR2 4DG	ribbon for certificates
R. Green, 94 Moseley Wood Gdns, Leeds LS16 7HU	recessed paperweights
Craft Creations Ltd, 1-4 Harpers Yard, Ruskin Road, Tottenham, London N17 8NE	greetings card blanks, papers, envelopes

Australia

Will's Quills,
164 Victoria Avenue,
Chatswood, NSW 2067

The Calligraphy Centre,
Shop 59, Myer Centre,
Elizabeth Street, Brisbane,
QLD

Calligraphy Centre,
960 White Horse Road, Box
Hill, Victoria

USA

Pendragon, 862 Fairmount Avenue, St Paul, MN 55105	all calligraphy materials

Index